IMAGES
of America

LIGHTHOUSES OF
SAN DIEGO

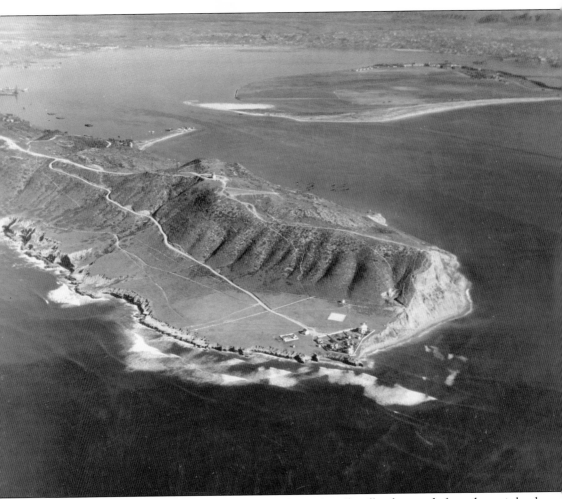

SAN DIEGO'S PENINSULA OF POINT LOMA. Nearly 5 miles of headland protrude from the mainland of San Diego. Bluffs rise 422 feet above the surf. Ballast Point, Old Point Loma, and Point Loma Lighthouses are all visible in this mid-1930s photograph. (San Diego Air and Space Museum.)

ON THE COVER: **POINT LOMA LIGHT STATION, C. 1945.** During its heyday, the lighthouse was meticulously kept by an officer in charge and two assistants, who proved jacks-of-all-trades. Personnel lowered shades at the lantern windows to protect the lens from sunlight. Flanking the tower are small beaches where residents once sunbathed and swam with sharks. What is not seen: a submerged shelf below the tower. Mariner, beware! (Lexie Johnson.)

IMAGES
of America

LIGHTHOUSES OF
SAN DIEGO

Kim Fahlen and Karen Scanlon

ARCADIA
PUBLISHING

Published by Arcadia Publishing
Charleston SC, Chicago IL, Portsmouth NH, San Francisco CA

Printed in the United States of America

Library of Congress Catalog Card Number: 2007943611

For all general information contact Arcadia Publishing at:
Telephone 843-853-2070
Fax 843-853-0044
E-mail sales@arcadiapublishing.com
For customer service and orders:
Toll-Free 1-888-313-2665

Visit us on the Internet at www.arcadiapublishing.com

To Point Loma's lighthouse brats: Lexie, Ken, Joanie, and Pat. Also to Jim, Janet, Alton, Jeanette, Kirk, and Allan. With our love. Your stories are special.

CONTENTS

ACKNOWLEDGMENTS

In acknowledging those who helped with our endeavor, Timothy and Jay Fahlen come first. Without their willing natures and skilled computer and scanning help, we would be . . . crying! We are amazed at the friends who have come into our lives through one little word—*lighthouse*. Joseph Cocking of Lighthouse Lamp Shop and Nicholas Johnston of Carolina Lens Works (both retired from the U.S. Coast Guard) gave us friendship and wonderful opportunities. Thomas A. Tag's punditry and friendship mean much.

Thank you historian Charles "Best Charlie" Best for your willingness to review the manuscript, hoping to catch us on something. He did! Rich Gales and Jeff Gales of the U.S. Lighthouse Society (USLHS) at www.uslhs.org, thanks a bunch for all your help. We adore the warm spirit with which Jan Mattson shared the Mollering scans and contributed the photographs taken by his father, George Mattson, and his uncle John Twohy in 1950. Carol Myers and Chris Travers of the San Diego Historical Society (SDHS) were delightful and trusted help. Colin MacKenzie, director of the Nautical Research Centre of Petaluma, knows the value of the information he sent. We are grateful to Karl Pierce for support and Tracie Cobb for access to the images of Cabrillo National Monument (CNM).

Thanks to EM2 Francisco Javier Lopez of the Coast Guard Aids to Navigation Team, we enjoyed the climb to Harbor Island Light. We appreciate Capt. Chip and Kathi Strangfeld for leaving the key "under the mat" while we studied Point Loma's tower. Blanca Soto, *queremos agradecerle el tiempo que pasamos con usted en Tijuana. Muchas gracias.* Kevin Sheehan of the Maritime Museum of San Diego (MMSD), thanks for your kindness. Naval historian Bruce Linder and Mark Allen (MMSD 2002), we relied on your insights. Thanks also to Gail Fuller, former historian of the Coast Guard Historian's Office (CGHO), and to the San Diego Automotive Museum for identifying old cars.

Let us not forget the endless patience of Karen's husband, Tom, and Kim's "houseboy," Edward. We thank Elizabeth and Tommy for, "How's the book, mom?"

The photographs are from the collection of author Kim Fahlen unless otherwise noted.

INTRODUCTION

City planners recognized that if "New Town" San Diego was to become a prominent shipping and commerce port—in competition with San Francisco and Los Angeles—a lighthouse on the peninsula of Point Loma was urgent, as was the dredging of the harbor entrance and bay. The channel of San Diego Bay was riddled with shoals that lay in wait under varying tides for the bellies of ships. Sea captains were forced to devise tedious routes to avoid them or to anchor off Coronado Island (it was an island then).

In 1850, the U.S. Coast Survey determined the site for a lighthouse on the tip of the high peninsula of Point Loma. It was advised that the 422-foot elevation would place the structure in prevailing low cloud and fog. That the site was not exactly in San Diego became a source of contention with the contractor, who happened to need a road from the dock to the summit for supply delivery.

Though many of the country's lighthouses are still in operation after 200 or more years, San Diego's first lighthouse served a short span of little more than 35 years—fog finally defeating its brilliant white beams. By the mid-1880s, spar buoys and bay beacons began to appear, marking high spots along the waterway. But more was needed.

In 1891, a new Point Loma Lighthouse was constructed at a lower elevation to more effectively serve mariners at San Diego. A secondary lighthouse inside the harbor entrance was lighted the previous year at Ballast Point, a low sandy spit nestled in the lee of the peninsula. San Diego required two lighthouses now: one for coastwise travel and to bring ships off the open ocean and another to guide vessels into the harbor and away from Ballast Point.

San Diego's lighthouse keepers and their families lived inside the protective arms of a military compound and were indelibly linked to war efforts at America's extreme southwest edge. Though the southern extremity of Point Loma had been set aside in 1852 as a military reservation, by then, the old harbor fortification of Fort Guijarros lay in ruins. The buildup of seacoast defense at the sleepy port of San Diego was underway when construction of the first lighthouse began in 1854. Gun emplacements were added in the 1890s, but there was no permanent military installation until the completion of Fort Rosecrans in 1904.

Interestingly, Fort Rosecrans took its name in honor of Gen. William Starke Rosecrans following his death in 1898. A West Point graduate, Civil War hero, and U.S. congressman from California, Rosecrans would have been president had he responded in timely fashion to the invitation of Abraham Lincoln to be his running mate.

Ballast Point's keeper of the bay beacons, James Relue Sweet, occasionally attended Saturday night dances at the new U.S. Army post. On one such occasion, he met Celia Aileen Rogers, a young woman who had migrated from Kansas. The two married on San Diego Bay aboard the vessel *Point Loma* on July 4, 1905. A speedy ceremony was necessary when the officiating clergy became seasick.

Artillerymen and soldiers were scattered over Point Loma, and many lived in underground barracks just beyond the lighthouse fence. Searchlights and a menagerie of large guns were staged

in the backyard of the station dwellings. Keeper James Dudley's daughters remember an incident that took place prior to the start of World War II. The schoolgirls were reading on the sun porch of the big house, where a large window contained 105 small panes of glass. The front door, with its large embossed pane, stood in a nearby alcove. When the February sun got too warm, the girls moved into the living room, closing the doors behind them.

"We were not there long," Joan said, "when KAABOOM! The big 16-inch gun went off. The glass in the front door blew into the sun porch, where shards of it embedded inches into the floor." (It is believed that this giant at Battery Ashburn, high on the hill, was fired only once ever.)

With the automation of lighthouses, the need for a manned light station on Ballast Point faded, and it was razed in 1960 to make way for the U.S. Navy's submarine facility. Today the lantern sits on an Old Town San Diego sidewalk. The bell tower was moved to a private residence in east San Diego County. The 900-pound fog bell was retrieved from the scrap yard for 5¢ a pound and, at last report, is kept in Florida with its private owner.

Time left its mark on Point Loma's working lighthouse, too. The giant prismatic lens—a modern marvel of the 1890s—stood motionless near the end of 1997. Station resident and Coast Guard commander Frederick Kenney recalled, "My friend David Tam and I were below the cliffs fishing. It was Veteran's Day last year. David looked up at the tower and asked me if the lens didn't rotate 24 hours. I told him it did. We stared at the light for some time and noticed the lens was not turning. I phoned operations to come out and have a look at it."

In U.S. Naval Medical Corps (USNMC) commander David Tam's words, "It felt funny not to have the sense of the light rotating and casting its light about. We climbed the stairs and noticed that the motor was still running but the lens wasn't moving." The Aids to Navigation Team was able to restart the rotation but also decided the time had come to cease operation in order to preserve the lens. A blue tarp, secured by a bungee cord, was draped over the quiet lens until a more befitting zippered canvas cover could replace it.

The future of Point Loma's leggy tower remains uncertain—its lifeblood gone. U.S. Coast Guard personnel removed the lens in 2001 and instead maintain solar-powered channel markers at the bay entrance, which reference the Point, cliffs, and rocks by use of a variable rotating beacon and sound signal at the lighthouse. "We're really doing the same things at the lighthouse today, but without so much style," admitted petty officer Mark Brookmole, the officer in charge of the Aids to Navigation Team, in 2001. "We're in the business of aids to navigation, and any sentiment toward them is often the by-product. Restoration and preservation falls to the communities that claim them." And so it is for San Diego, with an impressive collection of four lighthouse lenses held and cared for by Cabrillo National Monument.

Within the ongoing course of lighthouse preservation, the adult children whose families kept the light stations have come to certain notoriety. Few remain to recount what life was really like during their unique, isolated childhoods. In their desire to keep this maritime history alive, they also take pleasure in honoring their fathers, and for some, their grandfathers. As is so often true, children are too busy being children to have complete appreciation of a father's work until they become adults themselves. Today these adult children of San Diego's light keepers recognize that they experienced a moment in time that is no more, and will not be ever again.

One

SAN DIEGO'S
FIRST LIGHTHOUSE

*The contract made by the Treasury Department in 1851 for building lighthouses on the Pacific
Coast, has proved a fruitful source of difficulty, delay, and expense.*

—Hartman Bache
Report on the State of Finances, June 30, 1855

California had enjoyed statehood for just a year when the U.S. Coast Survey party traveled west
in 1851. The group was to chart the Pacific Coast and determine sites on which lighthouses would
be constructed by the federal government. Journeying through the Isthmus of Panama was only
the beginning of the difficulties faced by these men; survey superintendent A. D. Bache wrote
that constant was "the disparity between our pay and our expenses," and the threat of disease,
extremes of effort, difficulty in food preparation, and weather were daily challenges.

Urgency to light the western seaboard was assisted by the 1848 Gold Rush. The survey cutter
Ewing faced competition with gold fields as seamen unfailingly deserted. At times, officers effected
watch with "cocked pistols." Keep in mind, the *Ewing* was navigating by old charts the officers were
in fact working to correct. Despite the hardships, specific sites for nine West Coast lighthouses
were chosen—among them San Diego.

Construction of San Diego's first lighthouse began in 1854, but its signal was not sent to sea
until November 1855 due to notable delays: the contractor found that the lighthouse was not to
stand on convenient ground, but on the end of a 422-foot high peninsula known as Point Loma;
the ineffectual lighthouse administration was undergoing major reform, resulting in overdue
modernization of lighting apparatus to Fresnel lenses; and the bark *Oriole*, which was carrying
supplies, sank on the Columbia River bar.

Point Loma Lighthouse was to mark the harbor entrance and highlight the coast. Distinctively
the highest lighthouse in the country, the height of its focal plane at 462 feet became its nemesis.
At the waterline, air could be clear, but higher, prevailing low cloud and fog obscured the light.
Long hours, low pay, and isolation may offer why in just under 36 years of operation 11 keepers
and 22 assistants were stationed here.

The little lighthouse was ultimately deactivated and abandoned when a better-situated one
replaced it. Two world wars indirectly sustained it, and that it survives today to charm hundreds
of thousands of visitors a year is a wonder.

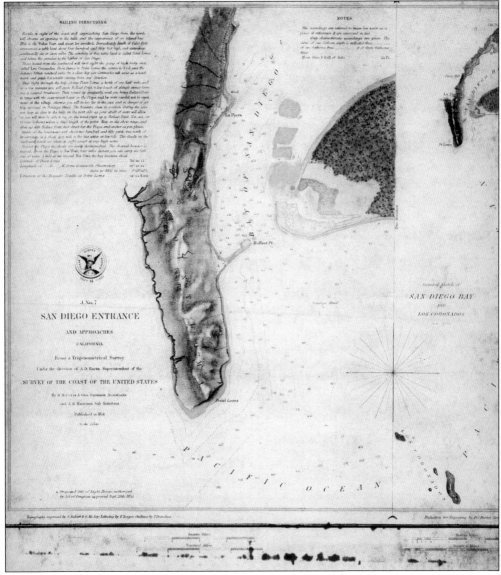

SAILING DIRECTIONS. The U.S. Coast Survey produced this 1851 chart, which sailing masters could purchase for 12¢. According to the small print in the upper left, "Vessels in sight of the coast, and approaching San Diego from the north will observe an opening in the hills and the appearance of an inland bay. This is the False Port, and must be avoided. Immediately south of False Port commences a tableland about 450 feet high and extending southwardly six or seven miles. The extremity of this table land is called Point Loma, and forms the entrance to San Diego. . . . Steer right through the kelp giving Point Loma a berth of one half mile, and in a few minutes you will open Ballast Point, a low beach of shingle stones forming a natural breakwater. Then round up gradually . . . being careful not to open more of the village, otherwise . . . you will be in danger of getting aground on Zuniga Shoal. The breakers show its position. . . . A mile or two beyond New Town the bay becomes shoal." (MMSD.)

NOTICE TO MARINERS.

LIGHT-HOUSE
ON
POINT LOMA,
BAY OF SAN DIEGO, CAL.

A FIXED WHITE LIGHT, 3d ORDER OF FRESNEL,
ILLUMINATING THE ENTIRE HORIZON.

This light-house is situated at an elevation of about 450 feet above the sea, and half a mile from the extremity of Point Loma, which forms the west point of the entrance into the Bay of San Diego. It consists of a stone dwelling of one story and a half, with a low tower of brick rising from the centre. The elevation will give full effect to the light, which in clear weather, should be visible, 20 to 25 miles.

Vessels from the north should give Point Loma a berth of half a mile, rounding-up gradually after passing it, until Ballast Point is brought in range with the Playa, being careful not to open more of the village than the most eastern houses, otherwise there is danger of getting on Zuninga Shoal, on the East side of the channel. Keep on the above range and when up with Ballast Point, within a ship's length of which four fathoms may be carried, steer for the Playa, leaving a shoal spot of 12 feet water, one-eighth of a mile inside the Point, on the port hand, and anchor off the village. From the Playa to New Town (new San Diego,) four miles, six fathoms may be carried. A mile or two above, the Bay becomes shoal. Vessels from the south should observe the same sailing directions, taking care to get on the range of Ballast Point and the Playa, south of a line half a mile seaward of Point Loma.

The latitude and longitude of the Light, as given by the Coast Survey, is—

Lat. 32° 40' 13" N. ;

Long. 117° 13' 16" W.

The light will be exhibited for the first time, on the night of November 15th, 1855, and thereafter, every night from sunset to sunrise, until further notice.

By order of the Light-House Board :

HARTMAN BACHE,

Maj. Topog'l Eng's, Br. Maj.

Office, 12th Light-House District,
San Francisco, Cal., Oct. 17th, 1855.

DELAY. The September 26, 1853, edition of the *Portland Commercial* reported, "Wreck of the Bark *Oriole* on the Columbia Bar, Total Loss of Vessel and Cargo." Lighthouse contractor Frank X. Kelly wrote that the *Oriole*, out of Baltimore, lay off the bar for eight days waiting for a pilot. At length, Captain Flavel's services were procured, and when wind proved favorable, the *Oriole* entered the channel. "Scarce had she gained the breakers ere the wind lulled, a strong tide running out forced the vessel among breakers, she struck in seventeen and a half feet of water, sprung a leak, and went down in fifteen minutes." With "two worthy boats on board," all 32 people put to sea, remaining all night until they were rescued by Flavel. One survivor stated that "from his knowledge of bar and coast [Flavel] was instrumental in our being landed safe." The *Oriole* was laden with construction materials for lighthouses such as Point Loma. As announced in the *Notice to Mariners* of the day, two more years would pass before San Diego had its lighthouse.

BACHE SKETCHES. Congress authorized the construction of nine West Coast lighthouses in 1850, though contractual setbacks plagued the project until April 1852. All would be of Cape Cod design, but at $15,000 each, only eight were actually built. The lighting system of Argand lamps with reflectors was originally ordered, but a long-needed reform of the lighthouse service gave way to Fresnel lenses, which Europe had been using for at least 20 years. The first Pacific lighthouse (above), on Alcatraz Island, San Francisco, began service on June 1, 1854. That year, Maj. Hartman Bache became inspector of the 12th Lighthouse District. Because he desired "that the board should possess a correct drawing of every structure as it is finished for its archives," early depictions of the lights can be observed today. Point Loma (below) was the last to be lighted.

VIEW FROM POINT LOMA LIGHT HOUSE, CAL.

REPORT ON FINANCES, 1855. Upon inspection of the newly built West Coast lighthouses, Major Bache declared, "Heedlessness of contract, lantern and apparatus procurement" and delays that "produced a complication of troubles," including "settlement of accounts in Washington and of enormous extra expenditure for useless work." This Bache sketch looks along the peninsula toward town.

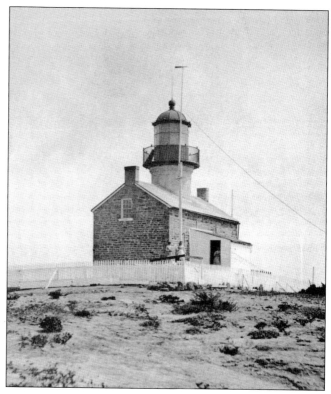

POINT LOMA LIGHTHOUSE, c. 1870. Shown here is the earliest known photograph of the lighthouse. The tower was built of brick and the dwelling of sandstone, with a roof of tin painted red when new in 1855. A sperm whale oil lamp provided the light, which was intensified by a third-order Fresnel lens. It did not flash but sent a steady beam to 360 degrees. (SDHS.)

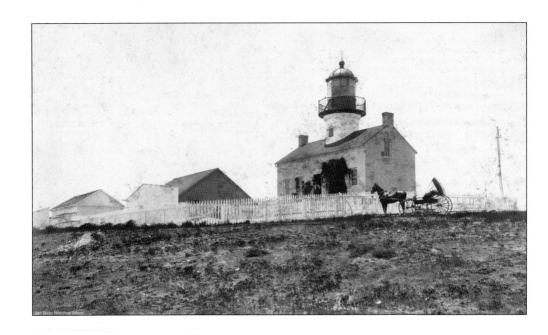

SIGNIFICANT HISTORIC PHOTOGRAPHS. For years, assistant keepers shared the single dwelling with the principal keeper, along with whatever family either had. In 1876, two rooms in the oil and wood storehouse above (with dark roof and siding in center) were fitted for added accommodation. Further improvements came in 1878, but the U.S. Lighthouse Board reported the storehouse "still unfit for quarters." The images on this page are particularly remarkable. Robert Decatur Israel began tending the lighthouse in 1871 and was promoted to principal keeper two years later; he leans against the lighthouse door frame, above, around 1880. Below, Israel stands at the left. On the lighthouse gallery are his wife and other family, as noted on a cropped version of this 1890 photograph. (Above, SDHS; below, CNM.)

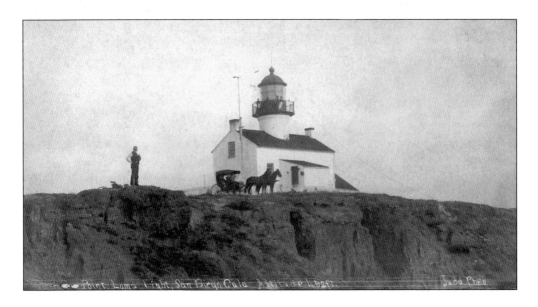

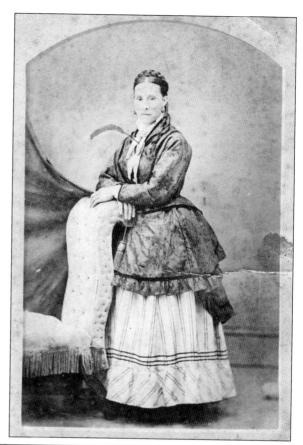

MARIA ARCADIA MACHADO DE ALIPAS ISRAEL. Captain Israel's wife was born of a longtime San Diego family, so her first language was Spanish. Insisting that California was now America, her husband forbade Spanish from being spoken in their home among their four sons—perhaps revealing why she is listed in service records as Mary. The Israels journeyed as far as 10 miles by buggy and team of horses for water at La Playa or to New Town for papers and sundry supplies not provisioned by the U.S. Lighthouse Board. A dentist named Dr. McKinstry seemed to find their sojourns worthy of mention, for in his diary of 1876, he noted 16 visits from June to December. Today Maria's handiwork is displayed in the lighthouse: two elaborate seashell frames and this delicate, hand-painted saltshaker (below). (Right, CNM; below, Kim Fahlen.)

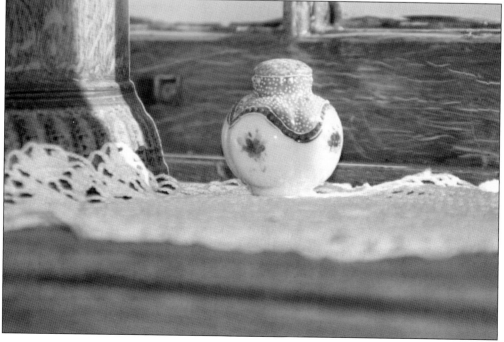

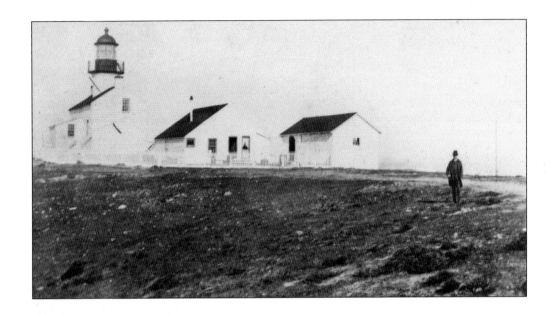

ENDING ITS ERA. Though these two *c.* 1888 photographs are similar, their historical value is individually significant. Shades lowered in the lantern and curtains hanging in the dwelling windows are the last vestiges of an active light station. Above, a gallery ladder gives access to handholds for cleaning the upper lantern glazing. The photograph below offers a sense of how isolated it really was at the end of the 422-foot-high peninsula. The foreground path led to the low extremity of Point Loma, where construction of a new lighthouse may have been underway at the time. (Above, CNM; below, the Society of California Pioneers.)

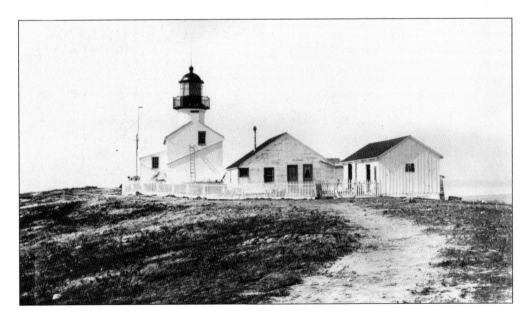

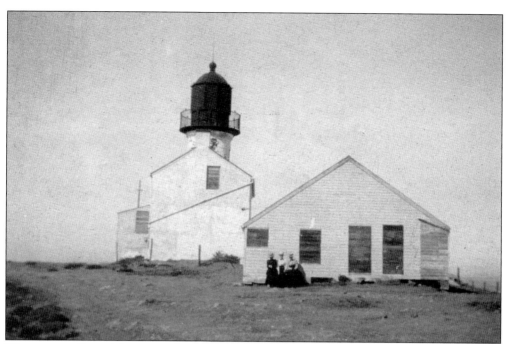

Woe to the Fog. After years of agitation for it, a new lighthouse was established—an act that left the old Point Loma Lighthouse abandoned. All openings were boarded (above) and the structures were to be looked after by Captain Israel. The 1876 barn was reportedly relocated to the new station, but with no intended use for the remaining buildings, vandals, exposure, and time soon began their destruction. The lighthouse optic was disassembled within the week of March 23, 1891, and shipped to the general Staten Island Depot in New York, its situation today unknown. Contrary to some reports, it was not placed in the new lighthouse. Two years prior, the characteristic had been reconfigured to fixed white varied by flashes, alternately red and white, with one-minute intervals between them. (Above, SDHS; at right, CNM.)

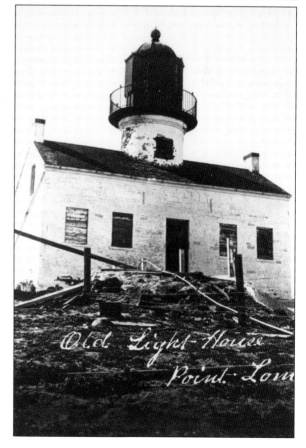

Old Light House Point Loma

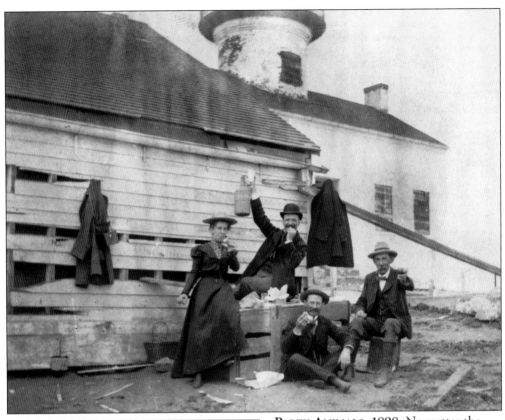

Party Animals, 1898. No matter the state of the old lighthouse, Point Loma has unfailingly captivated the senses of all who visit, including these day-trippers. The lady is wearing the height of fashion. (SDHS.)

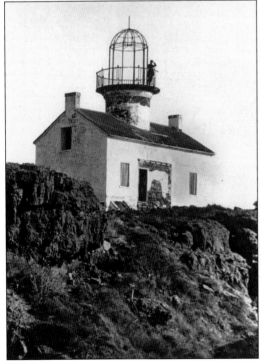

Recollections. Celia Sweet resided on Ballast Point between 1903 and 1912 (see chapter two). In an interview discussing the old lighthouse and its demise, she recalled that, within those years, "the windows were knocked out. . . . Everything they could take away was taken away. . . . It was a shame. . . . We felt terrible, bad about it. . . . Everything was being stolen off." (CNM.)

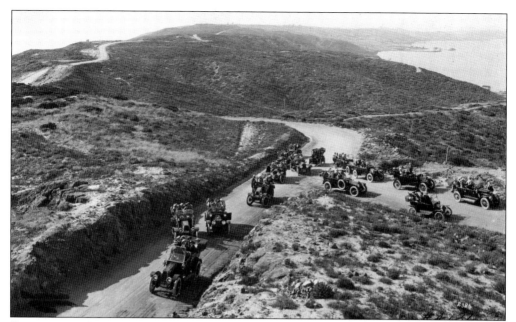

GOVERNMENT BOULEVARD. From the time the lighthouse contractors realized their San Diego work was on a 422-foot-high peninsula, access was troublesome. Ultimately, they sued the government—and won—for the $15,000 cost of a supply road. By 1910, increasing military domination demanded ingress to the ridge from all points. Compare this view from the lighthouse with Bache's sketch on page 13. (SDHS.)

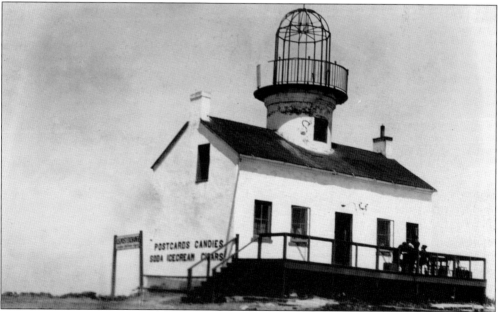

DELIVERANCE. The lighthouse had come to such ruin that it was on the brink of demolition in 1913. Fortunately for the lighthouse, if not for the proposed site usage—a 150-foot statue of Cabrillo with radio station or latrine in its pedestal—U.S. Army volunteers made repairs that stabilized the dwelling. Residency was encouraged to deter vandals, and around 1916, an Army Post Exchange offered the items noted on the wall. (Stan and Margret Butcher.)

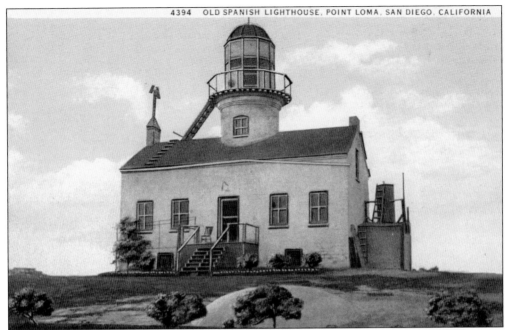

LA PUNTA DE LA PUNTA DE LA LOMA DE SAN DIEGO. "The point of the point of the San Diego hill"—this was the designation given on an old chart to the area on which the lighthouse stands. The lighthouse had a curious moniker for many years before and after World War II; it was called the Old Spanish Light, but there was nothing Spanish about it.

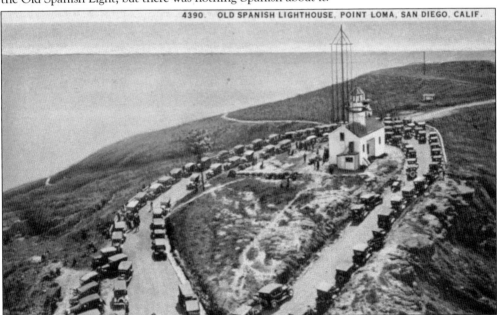

CABRILLO NATIONAL MONUMENT. In 1913, Pres. Woodrow Wilson proclaimed, "All the parcel of ground within the loop of the roadway of the Point Loma Boulevard where it encircles the old lighthouse" a national monument to the "discoverer" of California, Juan Rodríguez Cabrillo. This postcard depicts that parcel in the mid-1920s, when the lighthouse was a wireless station. Note the exaggerated radio tower. (CNM.)

OLIVE DRAB, C. 1943. For a time, the lighthouse served as a signal station, but here, painted in wartime color, it is viewed from another. In the foreground hang pennants and flags used to question ships for identification before they could pass through anti-submarine nets stretched across the harbor entrance. (CNM.)

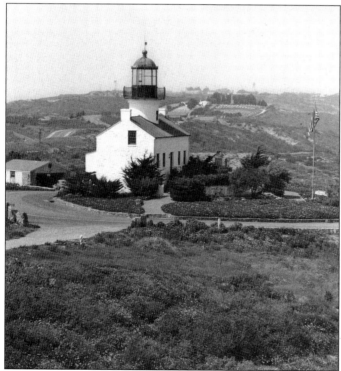

RECALLED TO LIFE. The U.S. Army administered Cabrillo National Monument until 1933, when it was turned over to the National Park Service. With conscientious research as to original design and materials, the lighthouse was rehabilitated in 1935. World War II stopped visitation between 1941 and 1946. With Fort Rosecrans National Cemetery in the distance, this 1949 photograph depicts a contented lighthouse in a glorious setting. (CNM.)

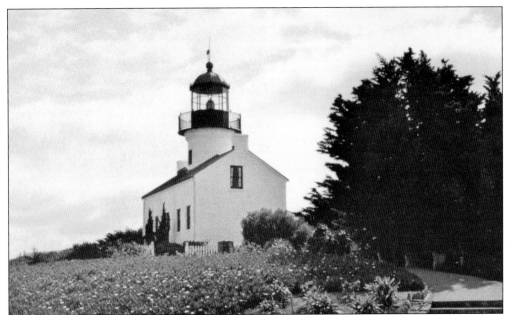

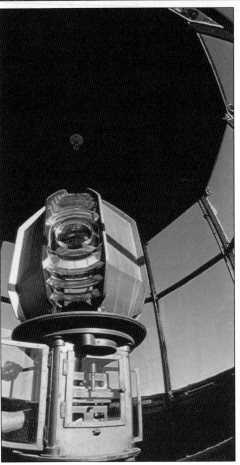

TRADING OPTICS. Washington A. Bartlett of the U.S. Navy was sent to France in 1852 to contract with Sautter and Cie in the manufacture of illuminating apparatuses for the new Pacific lighthouses. A "light of the first order" was wanted for San Diego; confusion over a first-order lens, the largest, led to the purchase of one oversized for the tower. The big one went to Cape Flattery, Washington, and a third order to Point Loma. When lighthouse automation rendered classical Fresnel lenses redundant, many were removed from lanterns. The U.S. Coast Guard began making "permanent loans" of the optics to museums. This beautiful octagonal fourth-order lens, having served both Humboldt Bay and Table Bluff lighthouses in California, was installed in Old Point Loma Lighthouse for its centenary celebration. (Both CNM.)

To Flash or Not to Flash. Beaming from the lantern today is an optic historically accurate to Old Point Loma Lighthouse: a third-order fixed lens (right). Manufactured by Henry-Lepaute in Paris, the lens is believed to have come from Mile Rock Lighthouse in San Francisco. Though lighted nightly, Old Point Loma has not been an official aid to navigation since 1891. During its last two years, a flashing character indicated Point Loma. Below is the eclipser, which created flashes from Point Pinos Lighthouse in Monterey. The eclipser rotated inside the lens by clockwork with descending weights. As the shield passed the eye, light was blocked; as light returned, its quick array appeared as a flash. An apparatus such as this may have been employed at Point Loma.

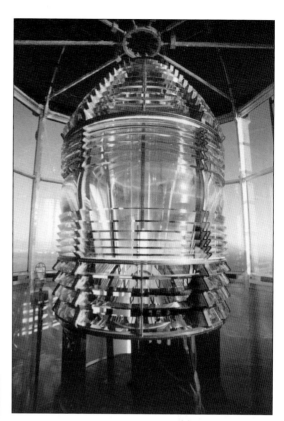

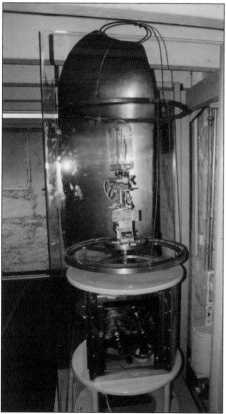

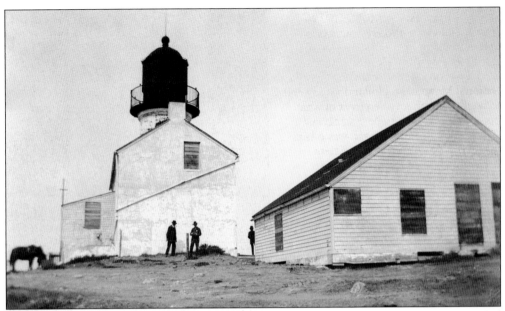

PERCEPTION. In 1874, the San Diego Chamber of Commerce stated, "The public is often misled with regard to a new country, by accounts of the tourist, whose vision was dazzled by its beauties, or clouded by prevailing shadows, during a visit of only a few inauspicious days." In an effort to counteract persistent flagrant misrepresentation, members proposed "to represent to the public the real truth relative to the condition, prospects, and peculiar characteristics of their flourishing young city" in confidence "that investigation and lapse of time will demonstrate that the representation is not overdrawn." Where better in San Diego than at Old Point Loma Lighthouse—abandoned by the U.S. Lighthouse Board (above) and safeguarded today by Cabrillo National Monument (below)—has time demonstrated more clearly that the chamber's representation was not "overdrawn"? (Above, SDHS; below, Kim Fahlen.)

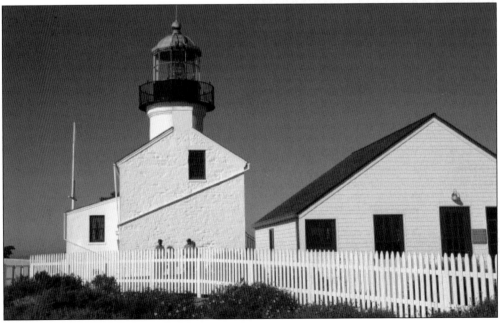

FRANCIS ROSS HOLLAND JR. (1929–2005). Holland authored a number of well-regarded books on the subject of lighthouses. He served as the historian at several national parks, including Cabrillo National Monument. Holland's study and archival research revealed most of what is known today about Old Point Loma Lighthouse. This photograph was taken during his last speaking engagement at Cabrillo National Monument in November 1996.

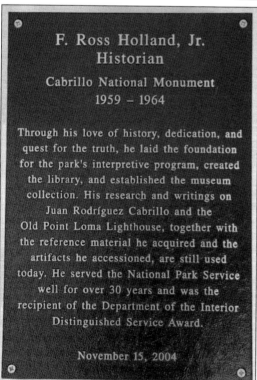

HONORS. Cabrillo National Monument enjoys a fine new museum storage facility. Just inside the entry is this plaque honoring Ross Holland. (CNM.)

25

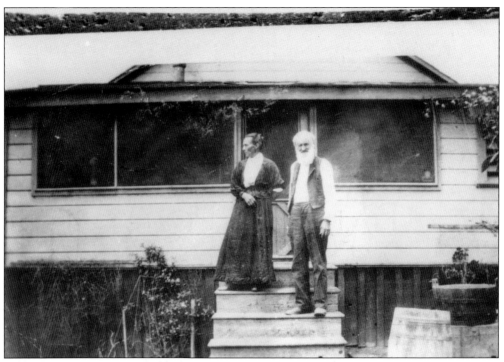

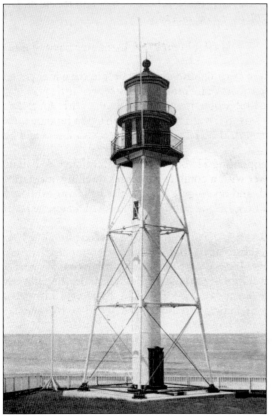

LAST LIGHT KEEPER. Former keepers of the old lighthouse are remembered for little more than their names, as scant details exist. The first, James Keating, was a shipbuilder; early assistants William Price, John Jenkins, and Enos Wall moonlighted as whalers. Israel's notoriety is derived as much from his place in time as his nearly 20-year tenure. Robert and Maria Israel are shown here after Robert's retirement ("removal") from the Lighthouse Service. (CNM.)

A NEW LIGHTHOUSE. It must have been exciting for keepers and families at the old light to relocate to beautiful new cottages when Point Loma Lighthouse was reestablished in 1891. Even though the new lens under their care was of the same third-order size, the flashing lens with 12 bull's-eyes was more tedious to clean—and one had to endure added stairs to reach it.

Two

BALLAST POINT LIGHT STATION

On December 7th [1941] when all the lights of the city were extinguished . . . they sent me out on the 83-footer to extinguish the buoys out at sea.

—Radford Franke, Ballast Point Light Station

It seemed the perfect site in 1850—but San Diego's first lighthouse was simply in the wrong place. The U.S. Lighthouse Board realized in just a few years that Point Loma possessed "little practical value" and had even determined as early as 1881 where it would be rebuilt. With America's commerce increasing rapidly, more and more aids to navigation were manifest, so funding for a new Point Loma Lighthouse had to wait its turn. Additionally, a secondary lighthouse would be imperative for lighting the harbor entrance.

Finally, in 1888, Congress passed a bill appropriating $25,000 for the establishment of Ballast Point Light Station. A square lighthouse tower with a combined keeper's dwelling, assistant's dwelling, and fogbell house were constructed, and on August 1, 1890, the light was exhibited for the first time. A fixed, fifth-order 1886 Sautter, Lemmonier lens lighted with kerosene lamp provided illumination for 11 miles.

Little realized today, the lighthouse itself was not the only light to be looked after. Much of that $25,000 was designated for establishing aids to navigation at the port entrance, channel, and bay and south to National City. The ever-increasing number of bay beacons became a major responsibility for personnel at the light station—to the point that, in 1889, the assistant keeper's dwelling was assigned to the keeper of the beacon lights. The 1911 Light List notes 18 aids to navigation in San Diego Bay, not including two fog bells actuated by the manual winding of clockwork.

Built in the late Victorian stick style, the structures of Ballast Point Light Station were winsome and beautifully tended for 70 years. But just as tide and current (and dredging) constantly altered the sandy spit, so too did time and modernization. By the late 1950s, more significant uses of the property had begun consuming the station, bit by bit.

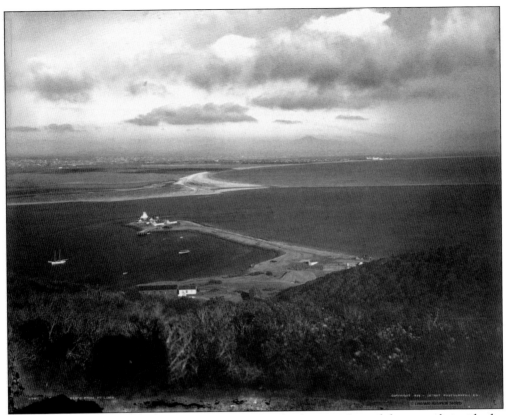

LA PUNTA. When California was still Mexico, the shoal jutting far and dangerously inside the harbor entrance was named Punta de los Guijarros. *Guijarro* translates to English as "pebble." Cobblestone washing from the San Diego River meshed with ocean tides and then caught on the banks. Because trading vessels were ballasted with stone garnered from this point, in time the site came to be known as Ballast Point. (Colorado Historical Society.)

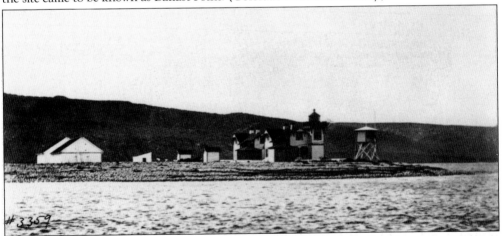

SEA LEVEL. Looking at this view of Ballast Point Light Station from the water, it is easy to see why keepers sorely resented when ships passed at too great a speed. Ships' wakes knocked loudly at their front doors. Continuously moving current created an average water depth of 62 feet in front of the lighthouse. (CNM.)

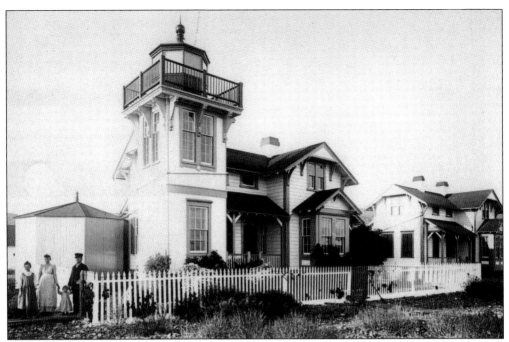

COTTAGES ON THE POINT. To reach Ballast Point Lighthouse from town, one had to travel 11 miles by wagon and 5.5 by launch. The bell tower and twin six-room dwellings were constructed in just three months in the spring of 1890. The photograph above is a companion to others dated December 13, 1893, and taken during a topographical survey of the station grounds. The keeper may be Henry Hall, since employment records note his assignment beginning on December 1, 1892. John M. Nilsson, assigned on July 15, 1890, served as the first keeper. As for the photograph below, there are no hints as to names or date, only that it was obviously taken when the structures were new. (Above, CGHO; below, National Archives.)

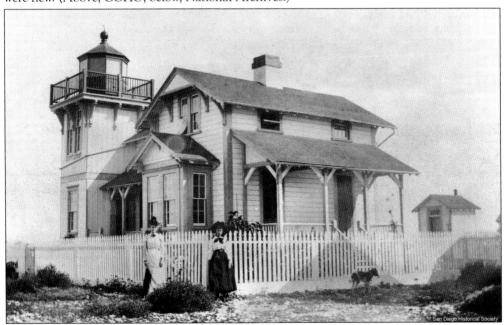

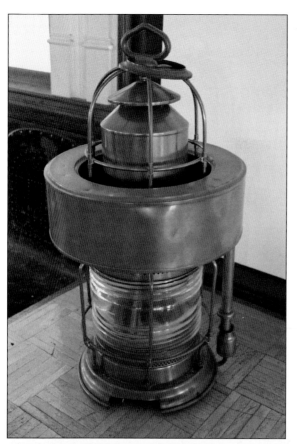

FUNCK LENS LANTERN. Unlighted Spar buoys were early types of navigational markers used in San Diego Bay. By 1889, at least six lighted "lens lanterns" such as the one shown here were placed at prominent locations to guide from the harbor entrance through the channel and to National City, inside the bay. U.S. Coast Guard Sector San Diego loaned this to the San Diego Maritime Museum, so it likely served San Diego.

EARLY AUTOMATION. The U.S. Lighthouse Board underwent intensive efforts to efficiently locate bay beacons. Needing no protective housing, some lens lanterns were placed on three- or four-legged structures onto which the keeper climbed to refuel tanks; others were suspended on poles or stakes. This lamp, along with the surrounding brass reservoir of the lens lantern, contained enough kerosene to stay lighted for eight days.

HARBOR LIGHT. Within its 1888 report, the U.S. Lighthouse Board determined, "The lighting of this harbor . . . has heretofore been largely left to private individuals. The Board is of the opinion that this practice entails an expense upon the merchants, which they should not be called upon to bear, and which is wrong in principle. Nor is it desirable to leave such commercial interests in private hands." (MMSD.)

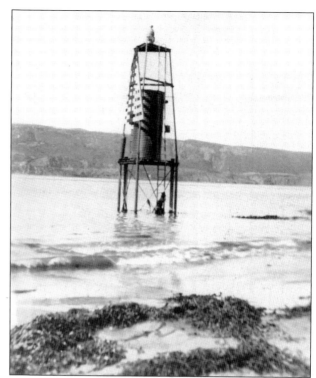

OOPS. This vessel is likely the cotton-trading *Belgian King*, beached on Ballast Point in 1895. An internet search finds that a ship named the *Belgian King*, owned by G. B. Hunter, foundered in 1914—where, it does not say. How the ship must have crunched into those cobblestones. (CNM.)

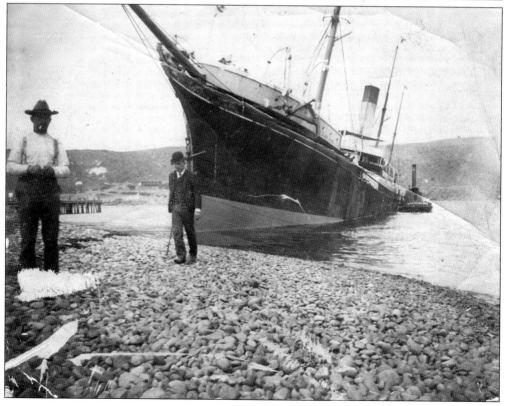

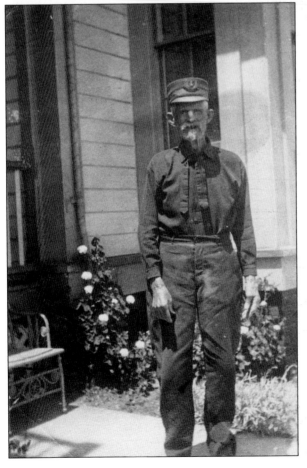

CONFOUNDING. These photographs might have been shown in chapter one, since David R. Splaine (above, right) served as assistant keeper at Point Loma Lighthouse from August 1886 to April 1889. In both images, he poses on the grounds of Ballast Point Light Station. Understanding his tenure is confusing because sources credit Splaine as having been the first keeper there; however, employment records of the U.S. Lighthouse Board list the date of his keeper appointment as August 1, 1895. He was made keeper of San Diego Bay Stake Lights on April 20, 1902, though it is noted, "Appt. expired June 1902." Another record places Splaine at Point Montara Lighthouse from June 1889 to December 1894. (CNM.)

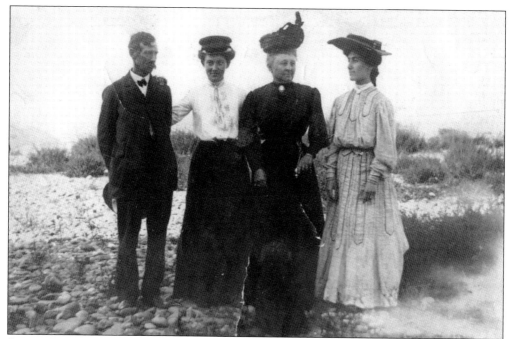

SWEET. James Relue Sweet was assigned "keeper of the Bay Beacon and San Diego Bay Stake Lights" from 1903 to 1912. Taking advantage of Sweet's carpentry skills, the U.S. Lighthouse Board needed to hire only one day laborer to assist in constructing a boathouse and ramp. Perhaps it was Sweet himself who captured his wife Celia, her father, and two of her aunts in this photograph. (James W. Sweet and Janet Sweet Corey.)

SKILL. James Sweet (left, with his family) was a designer and builder of such boats as the *Relue* (see page 35), constructed on boatways at the lighthouse in 1910. The *Relue* flew the San Diego Yacht Club Burgee, a club whose first meetings were held at the northerly lighthouse dwelling. A later Sweet boat, *Roller Bearing*, showed bursts of speed over 30 miles an hour. (James W. Sweet and Janet Corey Sweet.)

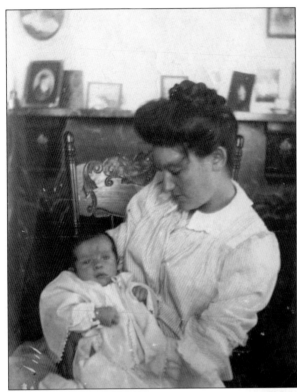

ROCK-A-BYE. Within these images, much is made of Celia—more so than of her husband, keeper of the bay beacons. At left, in the only known photograph of the interior of the lighthouse dwelling at Ballast Point, Celia cradles her baby Alton. Incidentally, the doctor had rowed to the lighthouse for the delivery and later forgot to record Alton's birth. "Dad had to do all the paperwork years later to prove he'd been born," recalled Alton's son James. Celia was the first woman in San Diego to become federally licensed to navigate motor vessels and carry passengers for hire. Below, Alton is dear, but it is Celia's wonderful dress that must be noted. (James W. Sweet and Janet Sweet Corey.)

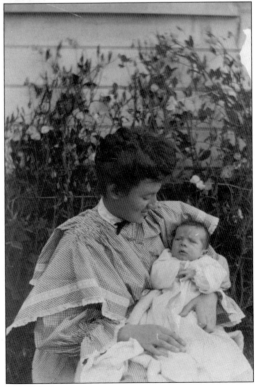

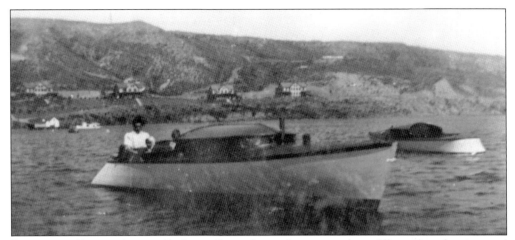

BEACONS, A FAMILY AFFAIR. For James Sweet, barnacle scraping, lamp filling, glass cleaning, and other lighting chores of offshore beacons were contests against swift tides. The station's alco-vapor launch *Sea Lion* could make 6 knots—no match for 9-knot currents. Sometimes beacon tenders waited out tides at North Island. Celia often accompanied her husband on runs to the beacons and learned to maneuver a boat with skill (above in the *Relug*). Note Fort Rosecrans on the hillside. In 1912, Celia earned a federal license (below) to navigate vessels. She competed against yachtsmen of the San Diego Yacht Club, as there were no women takers to her challenge, and won a series of races. Prowess on the water earned Celia a racing cup extended by the management of Tent City, the 1900 workingman's resort on Coronado. (James W. Sweet and Janet Sweet Corey.)

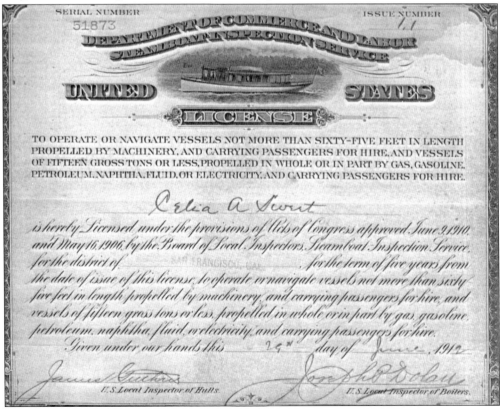

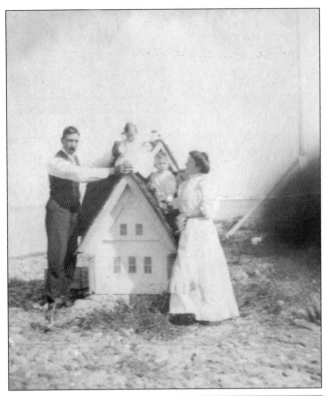

TENDER PAWS. The San Diego River emptied into the bay with contributions of silt and rock. Strong currents carried these rocks until they hung up on Ballast Point. Sweet fashioned leather booties for the family pet, its paws sensitive from walking over cobblestones. Shown at left with his children Verla and Alton and his wife, Celia, Sweet seems pleased with the doghouse he has made to resemble the lighthouse home. Note the doghouse below on the right. Structures from evicted whaling operations still remain, behind the bell house, in this 1908 photograph. Fort Rosecrans pipes water to the station's 9,000-gallon tanks. Outhouses are gone—imagine the family's elation when a bath and toilet were added in 1907. (James W. Sweet and Janet Sweet Corey.)

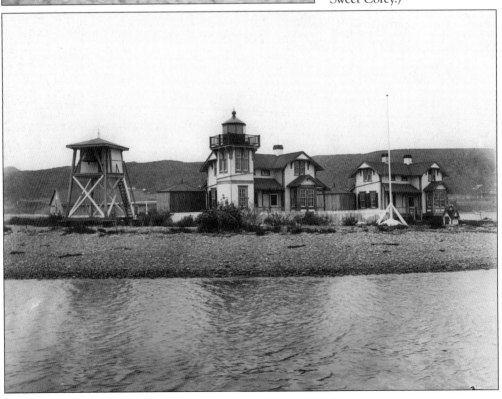

NOT ALL WORK. It would appear that life at the light station was most agreeable. Many children would thrive here through the years, but it could not have been without parental anxiety. In this image, note Alton's overalls and the charming wicker baby carriage with sizable wheels. (James W. Sweet and Janet Sweet Corey.)

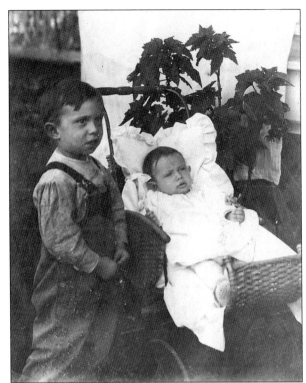

MILITARY MINGLING. The Sweets watched the 1903–1904 construction of Fort Rosecrans from their back door and made acquaintance with U.S. Army personnel. Standing among the Sweets are constructing quartermaster Capt. Robert H. Rolfe (center), and Lt. William H. Tobin (left, his young daughters in front). In 2003, Officers' Row resident Mary Ellen Cortellini identified the officers. (James W. Sweet and Janet Sweet Corey.)

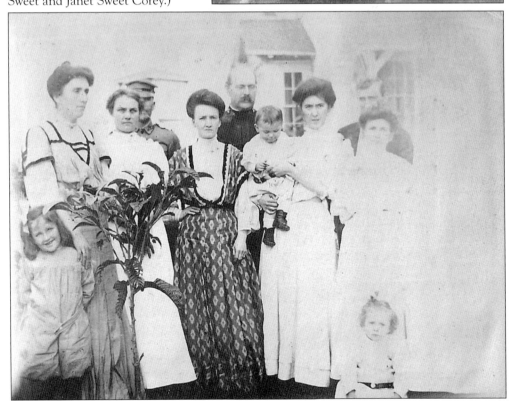

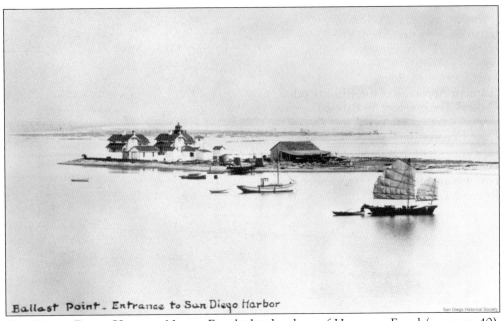

Ballast Point. Entrance to San Diego Harbor

TWO EARLY PILOT VESSELS. Norma Engel, the daughter of Hermann Engel (see page 40), chronicled her family's life at Ballast Point. Of the above image, she commented, "Just one lonely junk occupied by a solitary elderly Chinese rested in our waters." The man's vessel, *Hazel* (above, right), was the last remaining junk in San Diego. Norma recalled rowing out with her mother's baked goods for "Chinese." In the center of the above photograph is San Diego's first motorized pilot vessel, built by James Sweet and launched in 1907. It should not be confused with the second *Pilot*, seen below behind *Sea Lion*, launched in 1914 and restored by the Maritime Museum of San Diego in 2002. The U.S. Lighthouse Service launch (above, left of the three vessels; and below, center), with its identifying "USLHS," was fondly referred to as "the Useless." (Above, SDHS; below, Kenneth Franke.)

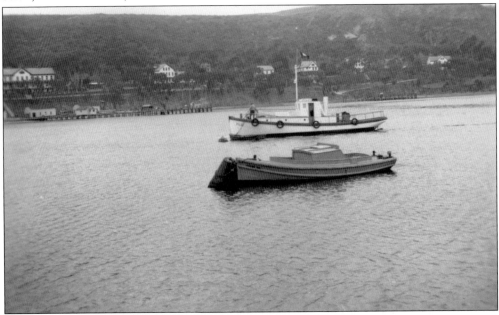

ARCHITECTURAL RENDERING, 1885.
Engineers from the Office of the
Lighthouse Board submitted detailed
drawings of lighthouses as they were
to be established. Rendered here is the
"Lantern Apparatus of the 4th, 5th, 6th
Orders." The ironwork for Ballast Point's
lantern was forged in San Francisco.
Once Congress approved funding, bids for
structures were advertised locally. Ballast
Point's lowest bidder declined and the
next was awarded the contract. (Nautical
Research Centre.)

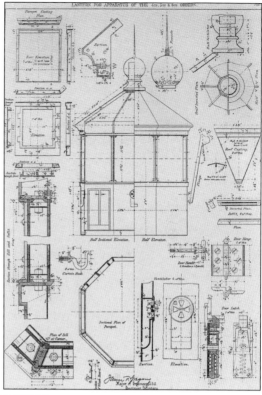

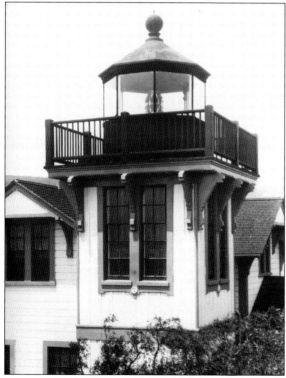

BALLAST POINT LIGHT TOWER. It
is a rare photograph that reveals the
lens in daytime. Lantern windows
were covered daily to protect the
prisms from the sun's intensifying
heat. The French firm Sautter, which
had manufactured the lens for Old
Point Loma Lighthouse, became
Sautter, Lemmonier, and Cie in
1870. The company constructed a
fifth-order lens for Ballast Point in
1886. (MMSD.)

THREE BEAMS OF LIGHT. In 1900, this newly wedded couple, Hermann and Freda Engel (left), made their first home on the Oakland Harbor Light, where Hermann worked as assistant keeper. Supported on 11 piles in San Francisco Bay, the lighthouse swayed in wind, rattled from the hammer of the fog bell, and "exhibited other sinister motions." Reassigned to Point Bonita Light Station, the Engels watched San Francisco burn across the bay from near their own earthquake-ruined dwelling in April 1906. By 1914, promotion had brought the Engels, now with sons Ray and Elmer and daughter Norma (below), to Ballast Point Light Station in San Diego. In 1986, Norma Engel documented her mother's and her own memories in *Three Beams of Light*, portraying an innocence of a time gone by when family, honest play, and hard work were valued. (Both Kirk Engel.)

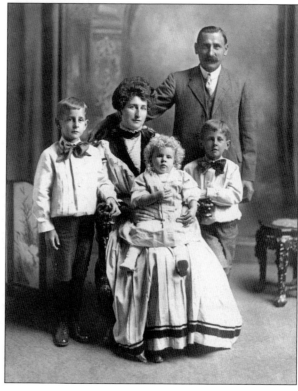

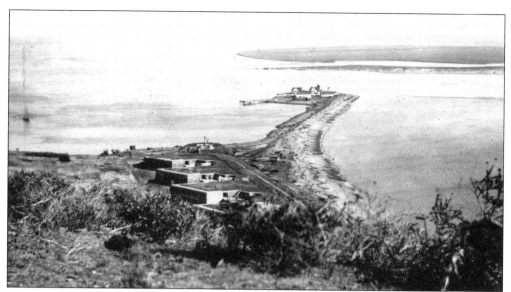

BATTERY WILKESON. By 1898, the federal government began increasing harbor protection with construction of the three gun emplacements shown above. A year before, 15 electrically controlled submarine (underwater) mines were planted in the channel by the Engineer Corps and volunteers; curiously, the mines were removed the next year. Keepers at Ballast Point were involved, since lighted buoys were darkened during this time. Visible across the channel above is Whalers Bight, the narrow inlet along the shoreline of North Island. Below, the floating gunnery practice targets corroborate a comment Norma Engel made in her book, "Although the scene of the war was far removed from us, we felt its impact clearly and forcefully from the activities near us." Note the laborious path to the lighthouse. (Above, Kirk Engel; below, SDHS.)

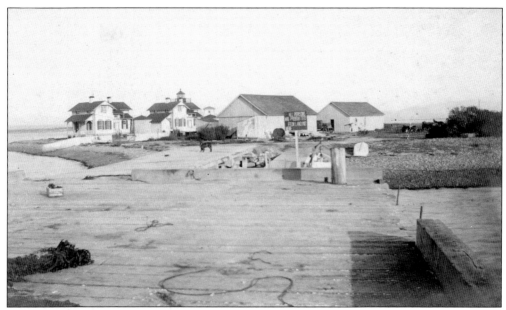

STATION NEEDS INCREASE. A wharf was constructed in 1903, stretching out to water 10 feet deep. Three years later, a concrete oil house and small storehouse for miscellaneous supplies were added. This large wharf would not have been built before 1920, when more land was acquired. The station ultimately became the lighthouse buoy depot for the more southerly stations between San Diego and San Francisco. (CNM.)

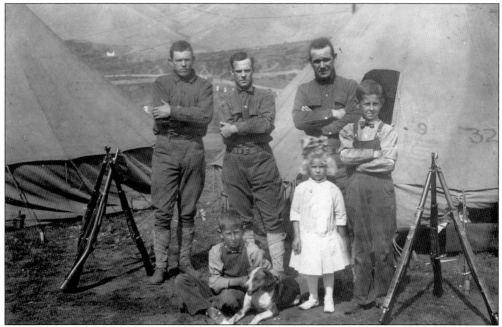

FUN TIMES FOR SOME. Dated July 1915, this postcard illustrates the playground of the Engel children—Elmer at age 12 (with the dog), Norma at 7, and Ray at 14. These kids enjoyed the freedom of exploring all around the Point, even walking to the ocean side to throw stones into the old uncovered Mormon coal pit. (Kirk Engel.)

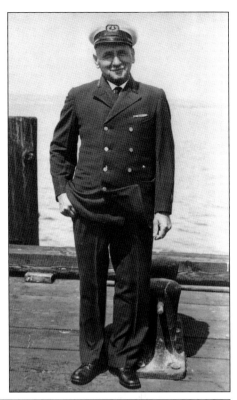

BUSY YEAR. In the endearing face of Hermann Engel (right) there is a sense of the humanity and conscientiousness with which he approached his work—and probably his life. The Lighthouse Board Annual Report of 1922 communicates that Engel "rescued a little girl from drowning" and "also rescued two women who had drifted out to sea." Further, he and "Harry H. Hoddinott, assistant keeper, assisted in securing help to float the schooner *Pacific*, which grounded at Ballast Point, also rescued two men from a sinking United States Army airplane." Planes taking off from North Island had to bank quickly, as they could not climb fast enough to avoid Point Loma. Below, Hermann and his son Ray assist during a rescue. At another time, a plane's steep dive angle sank it too quickly for help. (SDHS.)

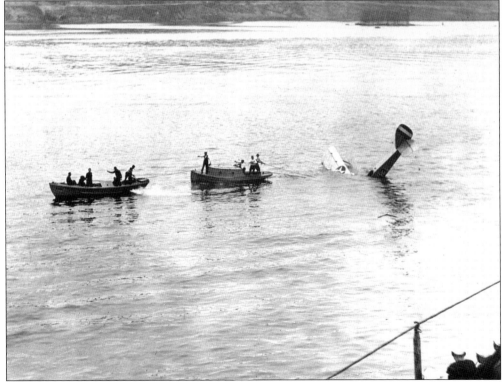

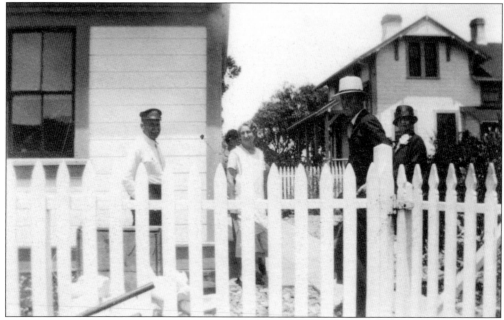

"Keeper Moving off Station." Hermann Engel noted his exit in the keeper's log entry of December 29, 1931. Decades later, his daughter would write, "The years of heavy physical work and the long hours shortened both my dad's life and years of service. . . . Finally, near the end . . . the government began to realize that this was asking too much of two men, . . . but there remains with me the wonderful memory that he lived exactly as he wanted." (CNM.)

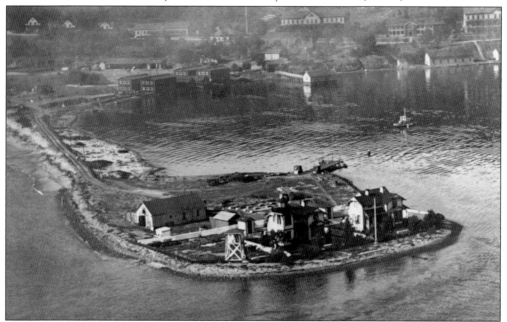

Whaling. A presidential order in 1852 created a U.S. preserve over the southern end of Point Loma. Three decades of shore whaling at Ballast Point followed. Today it is the site of fire pits, where grey whale oil was rendered in try pots, and is an historic landmark. This oil did not fuel San Diego's lighthouses. Here the large storage barn still exists in 1930. (Jeanette Mollering Johnson.)

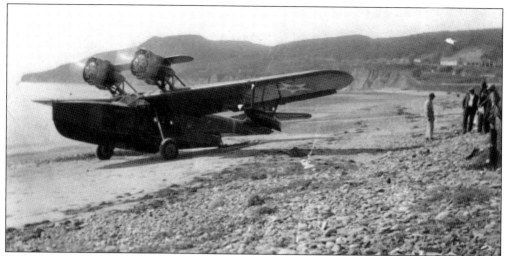

AMPHIBIOUS LANDING, C. 1933. A two-crew six-passenger Dolphin navigates to the sand off Ballast Point. Across the channel to the east is North Island; it is not known whether the U.S. Navy pilot landed the craft intentionally or missed his mark. The Douglas Aircraft Company produced just 58 Dolphins from an earlier 1931 model. U.S. Coast Guard and U.S. Navy pilots flew the "flying yacht" for search and rescue as well as patrol. (Kirk Engel.)

RIDE ALONG. Though this is a hazy sort of image, it allows for a drive along the tire-tracked roadway into the station. Electricity was installed in 1928; note the wooden wire spools. The original land tract given to the U.S. Lighthouse Board was .59 acre; in 1920, additional land was granted by the War Department, out to 1.86 acres. (Jeanette Mollering Johnson.)

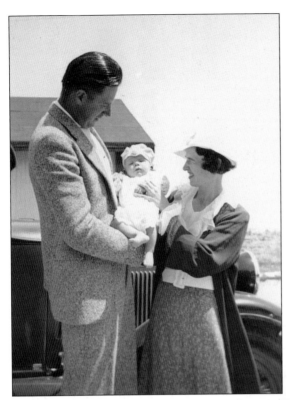

BABY MAKES THREE. November 1930 brought Radford and Marie Franke to "the best station along the coast." Having transferred from an island lighthouse, they were excited to find electricity in their dwelling. At first opportunity they bought a radio. The milkman delivered milk—a good thing with a baby to feed. Born in 1936, Kenneth is just eight weeks old in this photograph. (Kenneth Franke.)

LITTLE BOY AND BIG BUOY. Kenny plays while his father is likely out in a bigger tub of water—the bay—servicing buoys. In 1938, Franke's position continued as keeper of the bay beacons and required a lot of boat work; buoys as far north as Oceanside were his responsibility. It wasn't quite the quintessential vision of *lighthouse* keeping. (Kenneth Franke.)

BEACHWEAR. Grandpa Nels Peterson came to live with his daughter and son-in-law at the station. Here he holds fast to Kenny's trousers . . . or is Kenny helping to hold up grandpa? (Kenneth Franke.)

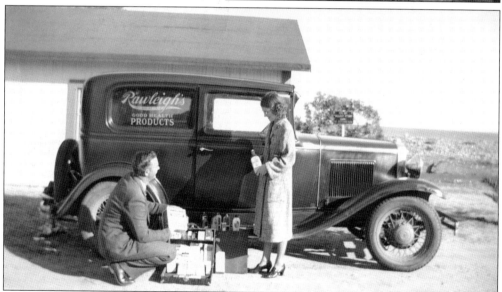

RAWLEIGH'S SALVES AND OINTMENTS. A Rawleigh salesman peddles his wares to Marie Franke at her lighthouse home. The name *Rawleigh* was synonymous with service, quality, and the direct-to-customer method. Taking his 1930–1931 Chevrolet out on the road bypassed the "jobber and dealer." W. T. Rawleigh began independent sales in Wisconsin in 1889 with a borrowed horse and mortgaged buggy. (Kenneth Franke.)

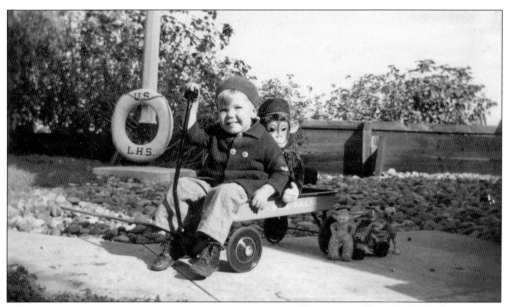

END OF AN ERA. In 1789, the ninth act of the new U.S. Congress established that all aids to navigation would fall under the responsibility of the federal government. The agency's title varied through the years: U.S. Light-House Establishment (1820–1852), U.S. Light-House Board (1852–1910), and U.S. Lighthouse Service or Bureau of Lighthouses (1910–1939). More than memories are captured in these Franke family photographs. Above, in January 1938, little Kenny and "Jocko" play near the station life ring with its identifying "U.S.L.H.S." The U.S. Lighthouse Service was abolished in 1939 and its duties transferred to the U.S. Coast Guard. Kenny poses at left with a new life ring, representing a new era in lighthouse administration. (Both Kenneth Franke.)

CANS AND NUNS. Inherent danger accompanied buoy work despite the casual poses of head keeper William Mollering shown in both images on a wave-activated bell buoy; note the bell and four clappers. Though the water is placid, imagine the scene in rough weather, which increases the likelihood of the buoy needing attention. In 1850, Congress standardized buoy color. Red and black denote a safe channel when entering a port—remember "red, right, returning"—thus mariners keep red to the right and black to the left when inbound. Buoys are bigger than they appear when bobbing on the water. A sinker is attached to a heavy mooring chain that is secured to the buoy hull. Fuel for lighted buoys was "pocketed" in hull compartments. Buoys were named according to their shapes; *nun* is an obsolete word for a child's toy top. (Both Jeanette Mollering Johnson.)

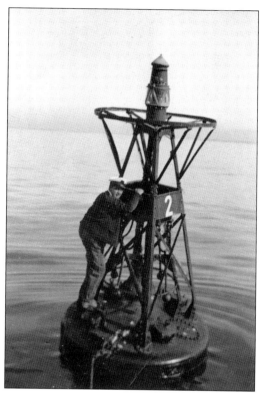

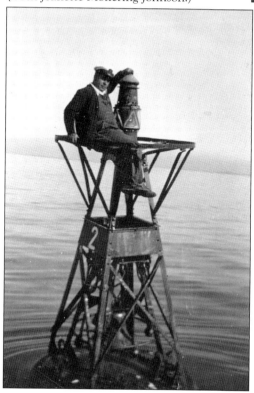

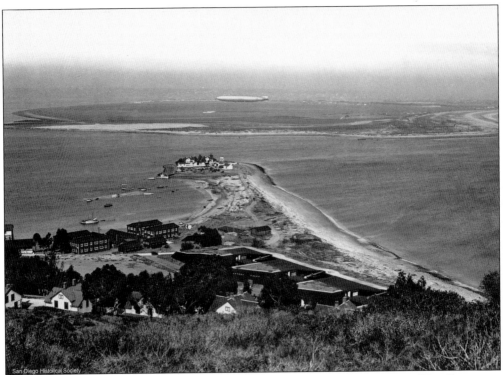

MILITARY PRESENCE. Ballast Point Light Station appears dwarfed by the activities of Fort Rosecrans. In the foreground, notice the 10-inch disappearing guns on Battery Wilkeson and, at left, the U.S. Army cantonment buildings. Across the channel, nose moored to mast, is the flying battleship USS *Shenendoah* (ZR-1) on its first call to North Island in October 1924. (SDHS.)

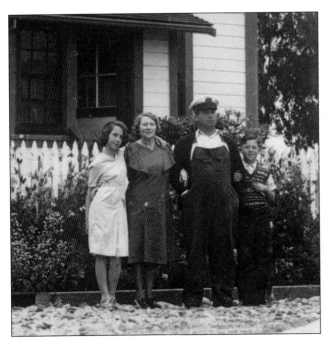

CURE FOR ANYTHING. William Mollering, his wife Jeanne, daughter Jeanette, and son Willy came to Ballast Point in January 1932 from Point Sur Lighthouse, north of San Francisco. As a little boy, Willy contracted whooping cough, so the family doctor recommended a desert or ocean climate. A friend suggested his father try the lighthouse service. (Jeanette Mollering Johnson.)

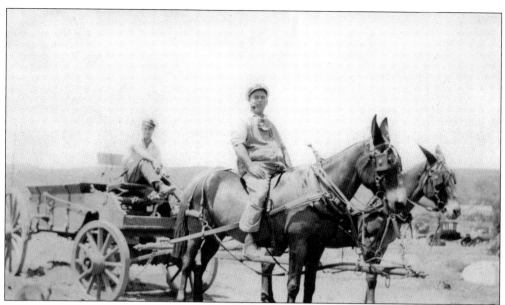

BEAUTIFYING THE STATION. Astride a mule, William Mollering gives a look of smug contentment. Load after load of earth was relocated in the ongoing, multiyear venture to improve the grounds around the lighthouse. This wagon's cargo is Radford Franke. (Jeanette Mollering Johnson.)

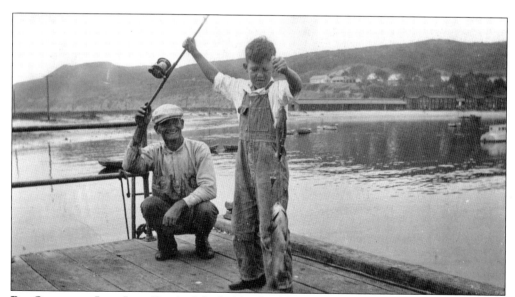

BIB OVERALLS, JUST LIKE DAD'S. It looks like the fish may be the only one unhappy about this catch. Willy's sister Jeanette recalled that her parents had many friends who often stayed the weekend, thinking it "the greatest thing. . . . We had row boats. They [parents] could see us 'cause we stayed in the bay. The pilot would take us out when he went out." (Jeanette Mollering Johnson.)

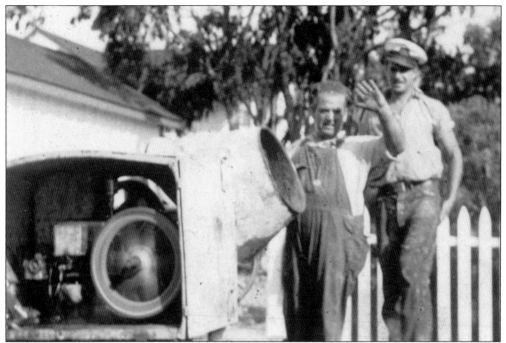

MIXING CONCRETE. There was never a work shortage for Mollering (left) and Franke, but Mollering's diligence and contentment at Ballast Point ended abruptly and sorrowfully in January 1938. While lighting up, he dropped the drawstring cloth that covered the lens in the daytime. While picking it up he hit his head on the lens pedestal. Days later, a blood clot formed and traveled to his heart. (Jeanette Mollering Johnson.)

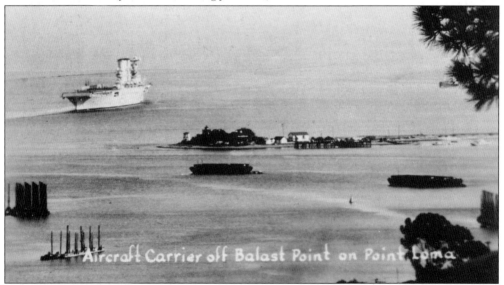

USS *SARATOGA* (CV-3). A frequent visitor to San Diego, the Lexington-class *Saratoga* slips along beveled waters, dwarfing Ballast Point Light Station. Naval historian Bruce Linder states that the *Lexington* and *Saratoga* "were identical sister ships and to tell them apart, especially for aviators flying around, the Navy painted a broad vertical stripe on *Saratoga*'s stack." In the foreground are UFOs: unidentified *floating* objects. (CNM.)

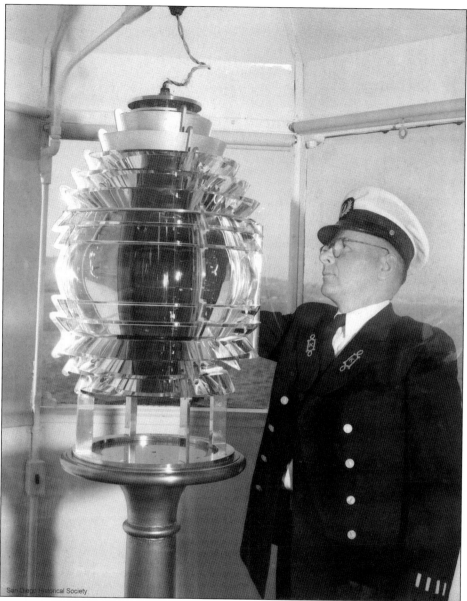

San Diego Historical Society

KEROSENE, ACETYLENE, ELECTRICITY. The year 1913 brought a change of light source to the lighthouse—the oil lamp was retired and a new acetylene-burning device commissioned. The acetylene produced a bright, white light, and within the next year, San Diego's bay beacons were also converted. By 1917, acetylene flashers were established in many of those. The 1938 Light List indicates a changed characteristic for the lighthouse: one green flash every two seconds. Placed inside the lens was a green glass globe through which the light passed, creating an emerald beacon to distinguish from the growing number of city lights. In 1928, electric light was sent through the prisms of Ballast Point's fifth-order lens. Again in 1938, the characteristic was altered, this time to a fixed green light. Standing in the lantern, keeper Steven Pozanac wears the U.S. Lighthouse Service uniform instituted in 1884. Note the roller blinds above the glazing (windows), the electric wiring, and light switch. When the lighthouse was demolished, Cabrillo National Monument requested this lens for its collection. (SDHS.)

SMALL LIGHTHOUSE WORLD. Steven Pozanac assumed the duties of Ballast Point keeper in 1938. Here he visits Point Loma Lighthouse with his wife, Minnie, whose father kept Lime Point Lighthouse in San Francisco. After serving eight years at Ballast Point and hurting his back in a slip off a buoy, Pozanac retired. He lived to age 102, outliving his only son. (Patricia Dudley Goulart.)

LOLLING TIME-OUT. It is not clear just when the redwood break wall first enclosed the station—photographs as early as 1930 show it. Sitting on it here from left to right are Pozanac, grandpa Peterson, and someone named Alex. The big wall-looking structure to the far right is a mammoth "Welcome Home" sign seen by thousands of sailors returning to the country after World War II. (Kenneth Franke.)

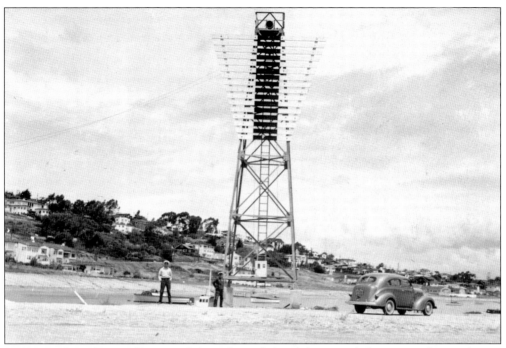

LA PLAYA REAR RANGE BEACON. Inbound vessels lined the range lights, one under another, to guide from the harbor entrance through the channel. Neighbors of this prominent signal recall police having difficulty keeping kids from climbing it. Radford Franke (left) and Steven Pozanac added this to their workload of lighthouse, dwellings, outbuildings, grounds, 24-hour watches, 53 other buoys, beacons, and two fog signals. (Kenneth Franke.)

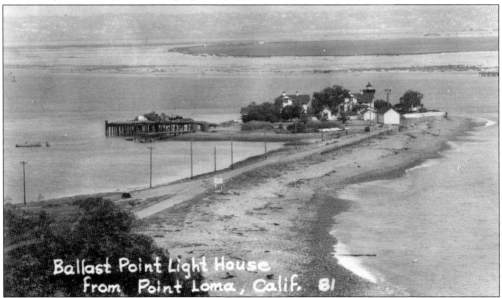

Ballast Point Light House
from Point Loma, Calif. 81

TOMBOLO. This *c.* 1935 postcard highlights the sand spit, or tombolo. The smaller wharf, barely visible by its large companion, gives an idea of the changed size of boats since 1890. Note the buoys on the dock. North Island looks poised to take on naval activity in the coming years; its shoreline will be reshaped when dredging spoils consume the bight. (Lexie Johnson.)

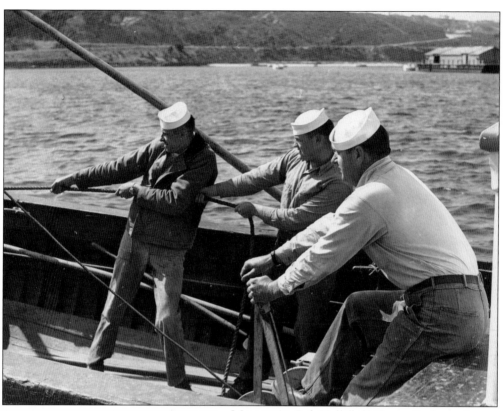

MAY 1950. Bob Hall (left) Kenny Pople, and Radford Franke (right) work a buoy on the station's 83-foot buoy tender. Maintaining these monsters involved more than lighting them. It was routine to haul them to the dock, where scraping, cleaning, and painting restored them for service. Often enough keepers had to repair damage from collisions with boats. (Photograph by Twohy/Mattson; Jan Mattson.)

TWENTY-EIGHT YEARS ON BALLAST POINT. Radford Franke (left) was only 23 when he came to Ballast Point as first assistant keeper. He worked and lived under the principles of the U.S. Lighthouse Service. For years after the institution became the U.S. Coast Guard, the old influence remained, but gradually congressional stinginess and Coast Guard impersonality gave way to BM1 Radford Franke's retirement in 1957. (Kenneth Franke.)

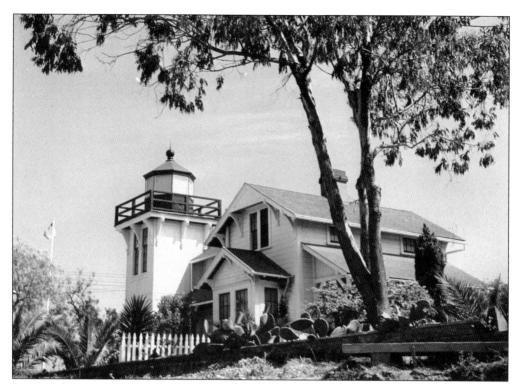

STARS. This particularly appealing vantage depicts a station well tended under Radford Franke in 1950. During the years of the Lighthouse Service, head keepers whose stations met exacting standards at inspections earned efficiency stars, which were worn on uniforms. Two or more superintendent's stars merited a commissioner's star. Both Engel and Mollering earned them annually. The U.S. Coast Guard did not continue the program. (Photograph by Twohy/Mattson; Jan Mattson.)

CONTRASTS. Six hours of leave on Sundays and two hours on weekdays left little time for outings like the one Radford and Marie Franke are enjoying here. On the night Pearl Harbor was bombed, Franke rowed in the darkness of San Diego Bay waters to extinguish all lighted beacons and quiet the bell buoy with burlap, wondering if a Japanese submarine was slinking nearby. (Kenneth Franke.)

FELICITATIONS. Light shines on oversized letters offering "Seasons Greetings" to passersby in 1956. The grassy yard barely resembles the natural landscape of 40 years earlier. When the highway along Point Loma was being built, Franke and Mollering hauled dirt to fill the area they had cleared of stone. (Kenneth Franke.)

KEN, MARIE, AND RADFORD FRANKE. That Kenny graduated from the California Marine Academy and joined the U.S. Coast Guard is not surprising considering his early boating ingenuity. His father recalled, "I looked over to see him floating on a mattress, life jackets holding up the two ends. He was sitting on an orange crate on the mattress with a paddle for an oar." (Kenneth Franke.)

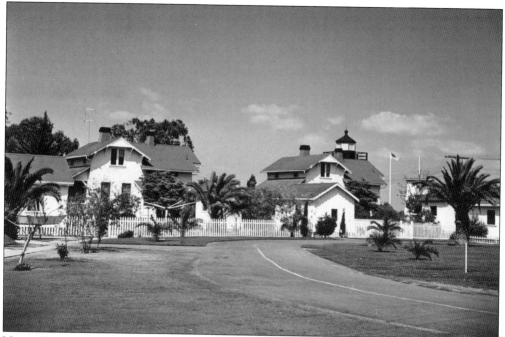

NEVER PRETTIER, 1950. A photograph like this brings the deepest regret that Ballast Point Light Station is no more. Kindly remember the lobsters that gave their lives, traded in burlap sacks, for the gallon-container palm trees planted by Radford Franke and Steven Pozanac. (Photograph by Twohy/Mattson; Jan Mattson.)

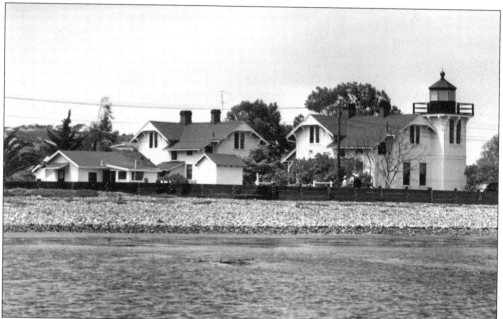

MARINER'S VIEW, 1950. Ballast Point Light Station was a handsome sight for ships entering San Diego. As the U.S. Navy moved on board in the late 1950s with submarine business, a new era on the small spit began to take a somewhat disheveled shape until old wharves and structures were rearranged or removed. (Photograph by Twohy/Mattson; Jan Mattson.)

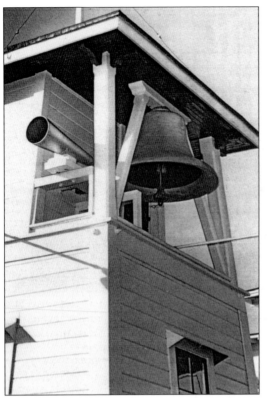

FOG AND FIELDS. This 900-pound bell (left) was struck every 10 seconds by clockwork. An underground hollow allowed increased cable length for the weight drop, thereby increasing the time between hand windings by the keeper. The bell became auxiliary when, in 1928, the electric single-tone diaphone sound signal was installed. At that time, the bell house was enclosed to protect the machinery. Ken Franke remembers envying the sound of the Point Loma Lighthouse diaphone, saying that "his" lighthouse "sounded like a goat entangled in a fence." Scrunched among station structures is the U.S. Navy's degaussing station (below, right). Submarines were running the range off Ballast Point by 1945. Degaussing was critical for neutralizing a ship's magnetic field as protection against underwater magnetic mines. (Both Kenneth Franke.)

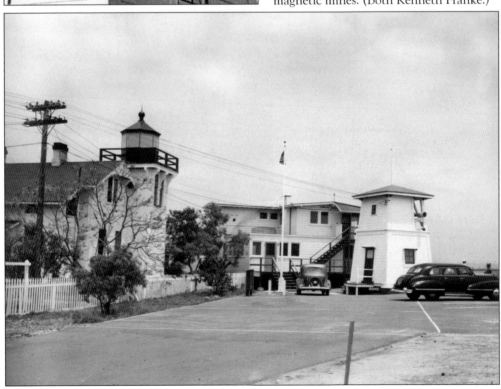

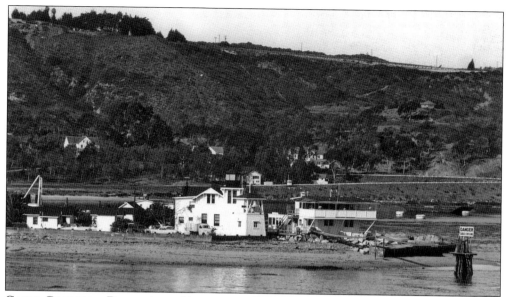

CABLE CROSSING. Degaussing cables cross underwater at Ballast Point, where ships pass at a specific course and speed. Naval historian Bruce Linder says that today degaussing engineering is performed farther north at La Playa. Nearby, in the early years of the light station, keepers maintained another harbor light and small fog bell at the old quarantine station.

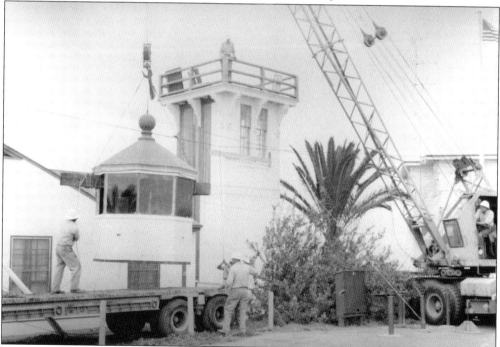

REMOVING THE LANTERN. In 1960, the lovely dwellings were demolished for increased station housing. The tower was left to stand alone; however, some time later, the brick-and-mortar foundation deemed it structurally unstable. Here the lantern is being lowered, and the tower will soon be destroyed. Today the privately owned lantern is visible on Congress Street in Old Town. (CNM.)

Ballast Point

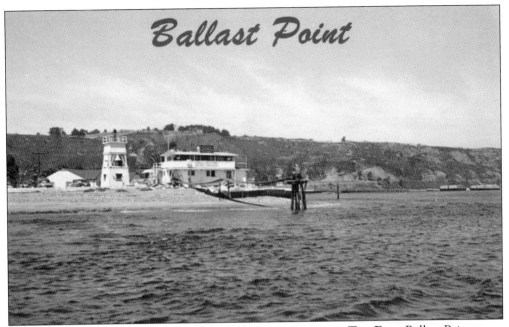

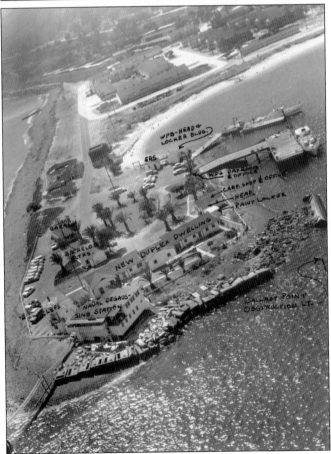

THE END. Ballast Point Light Station was altered over time to a light attendant station. A 375-mm lantern was attached to the old pyramidal bell house (above) and flashed a six-second occulting white light. The value of maintaining a light at the Point had decreased with the installation of new harbor entrance range lights, yet it was necessary as a point of reference in fog or haze. Note the 1962 obstruction light jutting into the bay. At left, new housing duplexes stand alongside the U.S. Navy's unsightly degaussing station on Ballast Point. Parcels of land were gained by the dumping of dredging spoils into the basin. Harbor Inn, a U.S. Navy conferencing center, occupies the site today, the short-lived duplexes having been removed. Few remember that a lighthouse ever existed on Ballast Point. (Above, Kim Fahlen; left, CGHO.)

Three

THE REESTABLISHED POINT LOMA LIGHT STATION

For all its isolation, we didn't mind it out there.

—Joe Brennan, keeper's son, 1892

Within hours of the extinguishing of San Diego's first lighthouse, its lens and lamp were dismantled by the superintendent of lighthouse repairs for shipment to the main depot on Staten Island, New York. On the evening of March 23, 1891, keeper Robert D. Israel, on his 68th birthday, lighted the wicks in the new Point Loma Lighthouse. Contrary to newspaper reports of the day, the lens from the old lighthouse was not transferred to the new tower—an impossibility in one day's daylight.

The station was reestablished on a 10-acre slope below the old lighthouse—its proximity to sea now more effective in steering ships away from disaster along the bluffs of Point Loma. But lighthouse engineers were plagued with troubles in the acquisition of the illuminating apparatus—troubles that delayed operation at the new station for months after the tower was raised. Frustrations ranged from disparity in the dimensions between more than one lens and the lantern to exhibitions at two world's fairs.

A pair of late-Victorian stick-style dwellings with lead-colored trim housed what was, in the early years, a lonely community of two families. In 1913, a third dwelling and engine house were added. Town was 7 miles away, but "it might as well have been across the country," Joe Brennan wrote. Travel by team or horse-drawn buggy was tedious over rutted dirt trails. Coal stoves and kerosene lamps required constant labor. Rain, the only source for water, was sometimes scarce. Though early images of the light station are black and white, resident families lived in full color and enjoyed the same consummate weather that makes San Diego so desirable today. There was little pollution in the 1890s; at most, garden garbage and discarded abalone shells were pitched over the fence.

Point Loma Light Station has been a crucial feature of San Diego's landscape for over a century, yet it has received little of the attention paid its more photogenic forerunner—until now.

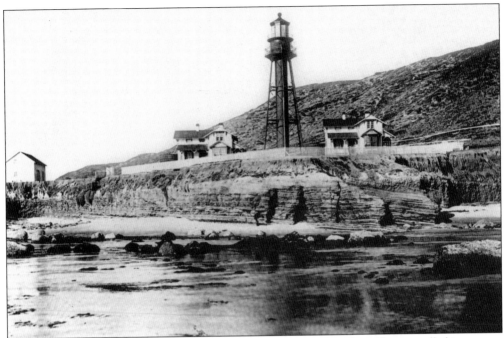

SAN DIEGO'S NEW LIGHTHOUSE. On July 5, 1890, California Southern flatcars rolled into town carrying 37.5 tons of iron tower. According to the *San Diego Union*, the skeletal tower was "hauled to the site on strong wagons" (no mention of strong horses). Forged at Phoenix Iron Works in Trenton, New Jersey, it was the only design of this type on the West Coast. (National Archives.)

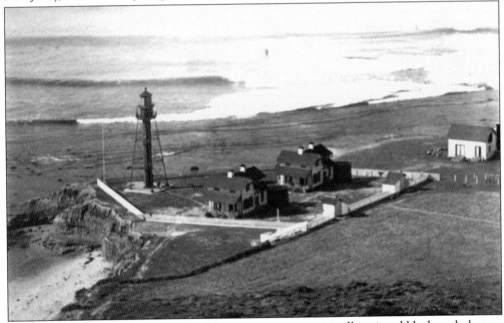

POINT LOMA LIGHT STATION, 1893. The iron tower was originally painted black or dark gray. It stands on a concrete block 25 feet square and 14 feet deep, which evidently did not interfere with the integrity of the cliff. A picket fence borders the grounds—a visual reminder to all that the cliffs beyond drop to the sea. (National Archives.)

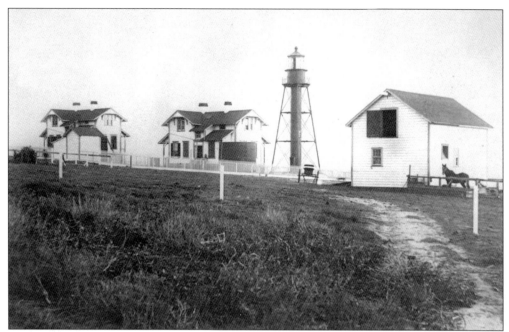

PERFECTLY SITUATED AND DISCONTENTED. The families of Captain Israel and his assistant, Thomas W. Anderson, surely enjoyed larger living quarters. Nevertheless, Israel stayed on at the new light for less than a year, still angered over a disagreement with the superintendent over a lost boat (while at the old lighthouse), which digressed into a fuss about the quality of cement in the water catchment. (USLHS.)

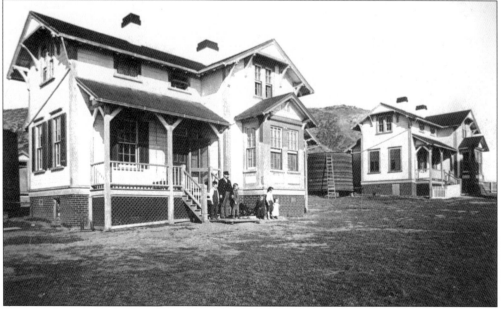

KEEPERS' DWELLINGS. Though unidentified, this keeper may be George Patrick Brennan, posing with five of his eight children. Brennan's son Joe became San Diego's harbormaster in 1918 and imagined the scheme to build up the shoal that evolved into Shelter Island many years later. Joe's four brothers all died in careers on the sea. (USLHS.)

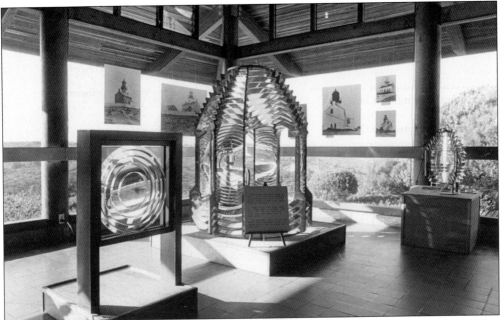

ILLUMINATION. A lighthouse lens was given an identifying number by its manufacturer. This optic, what remains of it, was originally ordered and designed for Point Loma as H-L330 (Henry-Lepaute). Never serving Point Loma, it instead became one of many frustrations for lighthouse engineers in fitting a lens in the new tower. Circumstances ultimately brought H-L330 to San Diego in 1968. (CNM.)

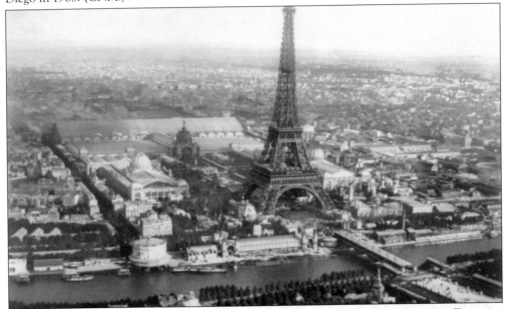

FAIRGROUNDS, 1889 PARIS EXPOSITION. Henry-Lepaute displayed its work of glass art at *Exposition Universelle de 1889*, an event that delayed the operation of San Diego's new lighthouse. The third-order Fresnel lens, which earned "two great prizes," was exhibited in the shadow of another demonstration of French technology: the Eiffel Tower. Eiffel's creation is the last standing evidence of that world's fair. (Library of Congress.)

G. W. Ferris's Amazing Giant Wheel. Delivery of Point Loma's optic was derailed again when its Parisian manufacturer requested that H-L330 be displayed at the 1893 World's Columbian Exposition in Chicago. Attempts at out-engineering Paris were successful with the introduction of the Ferris wheel. The giant steel structure rose skyward 264 feet, and each of its 36 wooden cars held 60 passengers. (Library of Congress.)

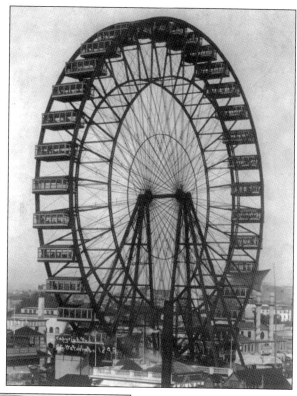

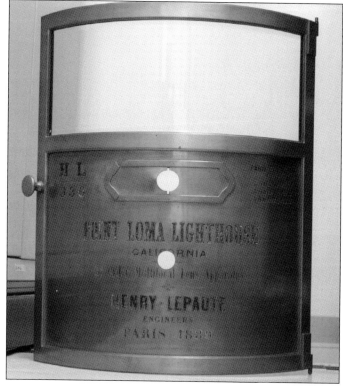

Pedestal Door of H-L330. When the exposition closed, H-L330 remained and served Chicago Harbor Lighthouse until the mid-1960s. National Park Service historian Ross Holland received word that the lens and a single door of its supporting pedestal had been seen cast aside in a Chicago naval depot. Holland negotiated delivery to San Diego. Today the lens rests in storage near its intended destination.

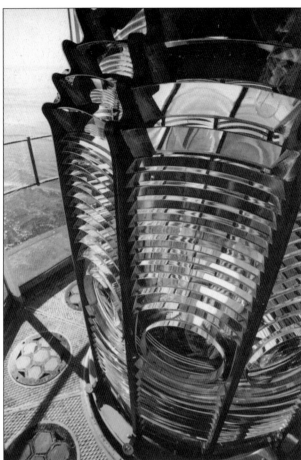

A $4,000 AFFAIR. In October 1890, lighthouse superintendent Frank Burke arrived to install another lens altogether, but alas it was too large for the lantern. A trade from the general lighthouse depot was ultimately installed, its pedestal bearing the words "Anclote Keys, Florida, 1887." A newspaperman somewhat flippantly described the glass as "a $4,000 affair from France."

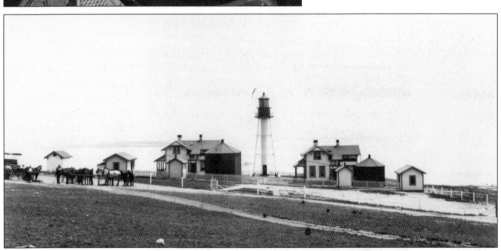

PAINTED TOWER, 1894. In this photograph, notice the high-flying flag and the fully exposed lighthouse lens. Perhaps window shades had not yet been installed. Large water tanks, outhouses, and a buggy barn came with the dwellings, but by 1895, multiple outbuildings were being constructed. The tower was painted white, making it more visible at sea during daylight hours. (Patricia Dudley Goulart.)

ROTATION. One method used to rotate lighthouse optics is by a chariot of friction rollers surrounding the central column of the supporting pedestal. Larger wheels circle the road carrying the weight of the cantilever, glass, and bronze; smaller rollers guide but do not make full contact. These chariot wheels gave Point Loma its signature characteristic: one white flash every 15 seconds. (CNM.)

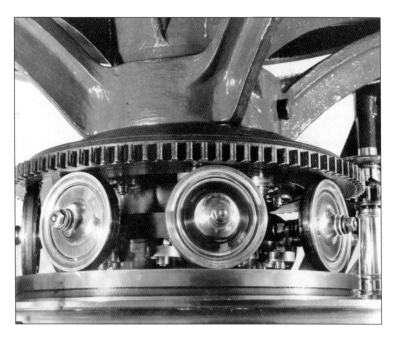

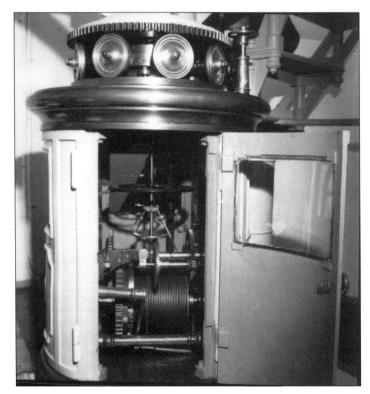

INSTALLED CLOCKWORK. Keepers wound a clockwork to achieve rotation of the lens, raising a heavy weight attached to wire rope. The rope wound around a metal drum (shown inside), and the weight pulled on the drum, turning it very slowly. Several internal gears worked in mesh with one attached to the base of the Fresnel lens. The whereabouts of the old clockwork is unknown. (CNM.)

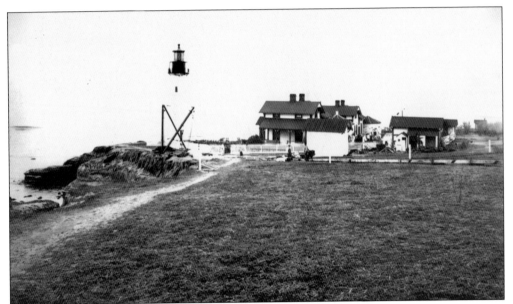

Barn Too Close. The barn from the old lighthouse was moved to the new station and placed nearly at the dwelling doors. When residents complained about the smell, the barn was supplanted elsewhere in 1896. Note the Anaconda Prospecting Hoist (foreground of tower), which raised supplies from the beach up the 30-foot cliff. (National Archives.)

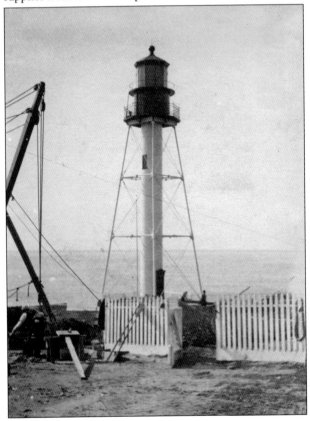

No Foresight? This photograph offers an interesting look at a day's work, but at what work, it fails to tell. In 1896, officials became concerned at the rate of erosion of the clay bank near the tower. The annual report noted that repeated measurements would be taken so as to prevent the undermining of the tower. (MMSD.)

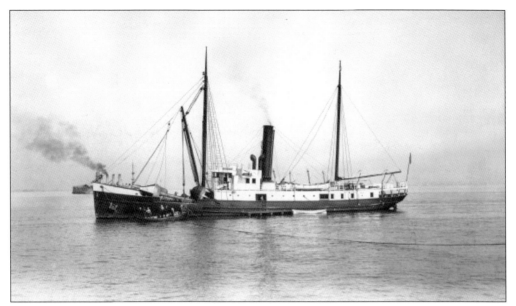

LIGHTHOUSE TENDER MADROÑA. Lighthouse tenders were federal ships critical to the support of lighthouses. The iron-hulled, steam-powered *Madroña*, built in 1885, was one of several ships that serviced San Diego's lighthouses. She served the U.S. Navy in World War I and was recommissioned to lighthouse service out of San Francisco in 1919. It was a big day when the *Madroña* arrived to deliver supplies. (USLHS.)

4224. Arched Rock near Light Hou_e, Point Loma, San Diego, Cal.

LOVERS' LEAP: FACT OR FICTION? It is entirely possible that one could leap over the soft sandstone formations at low tide (note the lighthouse lantern peeking between layers of rock). However, the veracity of this *c.* 1900 image is disputed. Natural sea-borne erosion, fluctuating sea levels, and time have continually altered marine sediment. These factors have erased this particular leap, but it existed. (Margaret G. Riddle.)

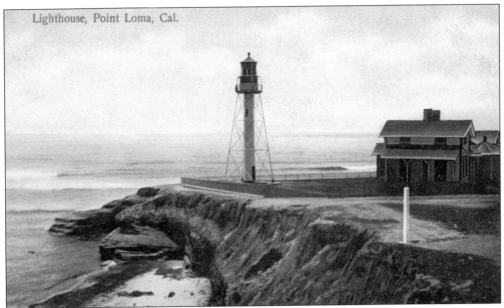

Lighthouse, Point Loma, Cal.

THEN AND NOW. Compare these images and note the geologic changes where continual lashing of the sea has eroded the rock upon which the lighthouse stands. A skeletal-type tower was intentionally selected for the new light station so it could be moved if necessary. In 1973, the Army Corps of Engineers dumped large boulders, or riprap, around the tip of the peninsula to curb erosion. Below, riprap covers the small beach that had been enjoyed by residents for many years. The tower stood alone, as above, until the engine house was added in 1913. The engine house sheltered machinery for the new, powerful compressed-air fog siren. Note the height of the palms in the 2002 image below; these trees were planted between 1915 and 1921. (Above, Lexie Johnson; below, Kim Fahlen.)

Four

LIFE AT POINT LOMA LIGHT STATION

They would fire those cotton-pickin' guns without warning us, and the Army shot shells right over our quarters. The windows would blow out. If they warned us, we could open them. But the Army replaced a lot of windows!

—Lexie Johnson
Daughter of the second assistant keeper, Milford Johnson.

San Diego's working lighthouse may have the aesthetic appeal of a rocket on its launch pad—hardly a vision in 1891—but the U.S. Lighthouse Service had function and cost in mind when installing the 70-foot skeletal tower. From its lantern, a red and white signal was sent to sea. By 1912, however, the ruby glass screens attached to every other of 12 lens panels were removed—red being a weaker signal. The change altered Point Loma's identifying characteristic to one white flash every 15 seconds.

Personnel coveted assignment at San Diego, and living on Point Loma required the collective vigilance of all who called it home. Even today, admits station resident Kathi Strangfeld, "Boaters get into trouble out here. The privilege of living at a lighthouse requires us to be alert to these things."

The light station grounds were confined within a military reservation. At the time, the keepers' children did not realize the unique aspects of their everyday lives—that school buses were canvas-topped trucks from the motor pool, and private beaches required armed guards. They roller-skated in underground barracks and climbed abandoned World War I searchlights. Hundreds of soldiers lived just outside the lighthouse compound, and lighthouse kids had similar status. James Dudley's daughter Joan remembers having to wear dog tags and taste malt tablets. Her sister Pat recalls the day of the attack on Pearl Harbor, "I counted fighter planes leaving San Diego until I couldn't count anymore. I heard my parents talking and it frightened me."

The ensuing blackout over Point Loma found lighthouse personnel oddly disoriented—the light in the tower dark, and five guards, in shifts, standing 24-hour watch from the engine house. It was six months before keepers carried on lighthouse business as usual.

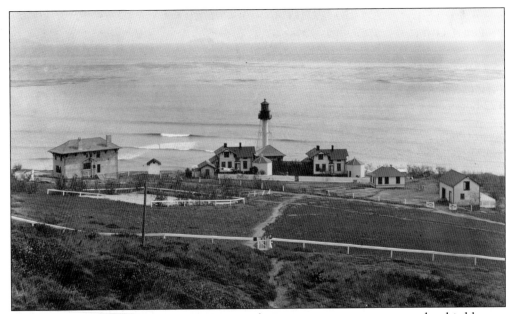

POINT LOMA LIGHT STATION, 1913. Increased maritime commerce warranted a third keeper and dwelling (pictured incomplete). Here the original kerosene lamp inside the lens has been replaced with an incandescent oil vapor light. Breakers push to shore over a submerged shelf where, in 1909, the schooner *Alice McDonald* was stranded, becoming one of many ships whose captains cut too close rounding the tip of Point Loma. (Lexie Johnson.)

LIGHT TOWER. In 1950, longtime friends John Twohy and George Mattson photographed California lighthouses for a book project that was not realized for another 50 years. George's son Jan and Twohy produced photographs from these early negatives and published *California Light Stations and Other Aids to Navigation* in 2001. Here Twohy and Mattson highlight the cylindrical tower—a "welcome home" for many. (Photograph by Twohy/Mattson; Jan Mattson.)

FIRST FOG SIGNAL ON POINT LOMA. A compressed-air fog siren (left) was commissioned in 1913. Driven by a 22-horsepower gasoline engine, an air compressor delivered sufficient pressure to blow the siren within five minutes. A 3-second blast sounded every 17 seconds. In 1933, the siren was replaced with the guttural call of a two-tone diaphone. (Photograph by Twohy/Mattson; Jan Mattson.)

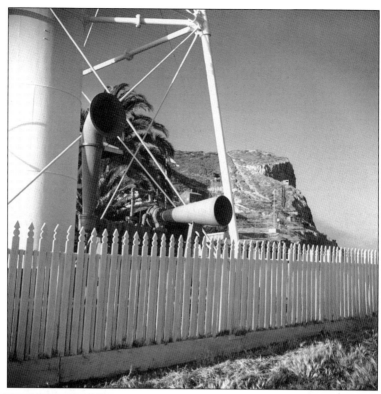

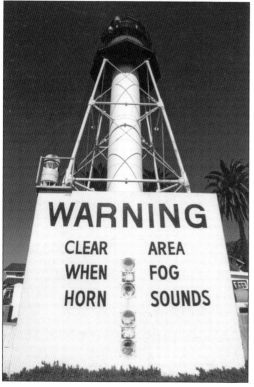

WARNING
CLEAR AREA
WHEN FOG
HORN SOUNDS

WARNING! Fog is serious business. Maintaining fog signals often kept keepers busier than any other lighthouse chore. "Point Loma's signal had a beautiful sound and we could hear it if the wind was right," remembers Ken Franke. "It hiccupped: every third 'bee-oooop' came out 'bee-op.'" Note the small electronic fog signal on the wall.

[Handwritten service card with fields for employment, position, pay, physical description, and service record of Eliot Dudley, born Guilford Conn 1902]

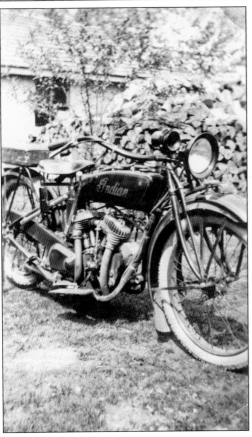

DEPARTMENT OF COMMERCE, LIGHTHOUSE SERVICE CARD. Though this card does not relate directly to Point Loma, it is rare paperwork. It records James E. Dudley's service aboard the lighthouse tender *John Rodgers* in 1919 and his transfer to the *Larkspur* the next year. The card was carried in a pocket as a form of identification. Dudley's career in lighthouse service brought him to San Diego. (Patricia Dudley Goulart.)

TRANSPORTATION, 1922. James E. Dudley and a friend left their hometown of Guilford, Connecticut, on this Indian motorcycle and headed west to California after Dudley's honorable military discharge in 1920. He was called home following his father's death. Before his assignment at San Diego in 1928, Dudley served the desolate St. George's Reef and cozier Los Angeles Harbor lights. (Patricia Dudley Goulart.)

DEPARTMENT OF COMMERCE LETTERHEAD, 1922. Scads of documents, including some regarding early lighthouse activity, were destroyed in a fire at the Department of Commerce in the 1920s. If not for family collections, many of these records would be lost. This document of the Appointment Division sends Dudley on his way again. (Patricia Dudley Goulart.)

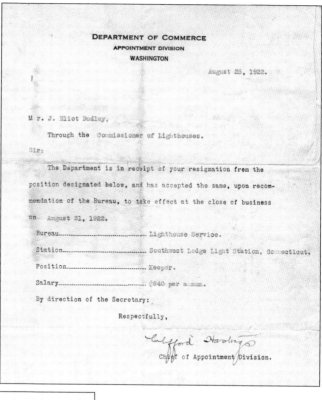

DEPARTMENT OF COMMERCE
APPOINTMENT DIVISION
WASHINGTON

August 25, 1922.

M r. J. Eliot Dudley,

Through the Commissioner of Lighthouses.

Sir:

The Department is in receipt of your resignation from the position designated below, and has accepted the same, upon recommendation of the Bureau, to take effect at the close of business on August 31, 1922.

Bureau... Lighthouse Service.

Station... Southwest Ledge Light Station, Connecticut.

Position... Keeper.

Salary... $840 per annum.

By direction of the Secretary:

Respectfully,

Clifford Hastings

Chief of Appointment Division.

PRIVATE BEACH, EARLY 1930s. With the tide out, young lighthouse keeper James Dudley clambers along the beach near his home. Low tide exposes the broad, submerged shelf that, at high tide, lies beneath 15 feet of ocean. It is not uncommon for vessels to ground on this hidden menace. Keepers have rescued a number of unwary, frightened passersby. (Patricia Dudley Goulart.)

Mr. and Mrs. Charles Clifford Warner

announce the marriage

of their daughter

Violet Ethel

to

Mr. James Elliot Dudley

on Saturday, the eighteenth of October

nineteen hundred and thirty

Beverly Hills, California

At Home
Light Station
Point Loma, California

THE KEEPER AND HIS BRIDE.
"Our mother, Violet, was visiting San Diego with our grandparents in 1929," says Joan Eayrs. "For entertainment they took her out to see the lighthouse. When they finished the tour, the first assistant asked if Violet would like to see his baby chicks." The rest is family history. James E. Dudley and Violet Ethel Warner (below) were married the next year; the announcement (left) informs the recipient that the couple's home will be made at "Light Station, Point Loma, California." The new bride had no electricity in her dwelling and instead lighted kerosene lamps. A footed bathtub, coal stove, and a husband's low pay were part of the package, as was the ocean view from every window. (Left, Joan Dudley Eayrs; below, Patricia Dudley Goulart.)

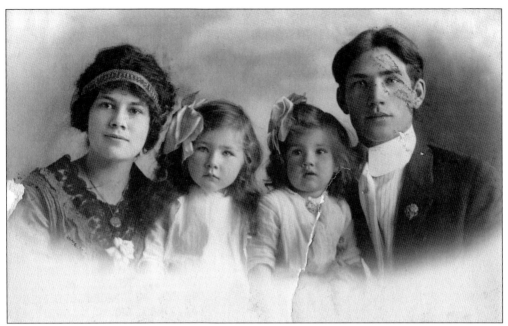

A Tie to San Diego's Naval Disaster. Business was progressing as usual along San Diego's waterfront in the early hours of July 21, 1905. Then two successive boiler explosions aboard the patrol gunboat USS *Bennington*, at anchor in the stream of the bay, plundered the ordinary. The incident remains one of the deadliest peacetime disasters in the history of the U.S. Navy. In January 1908, a granite obelisk monument, seen below, was raised at the post cemetery to honor the 65 sailors and one naval officer killed in the explosion. Sounding taps was lone bugler Charles Clifford Warner, a member of John Philip Sousa's marching band. Warner is shown above with his wife, Ethel May, and daughters Violet and Margarite in 1914. Violet grew up and married the light keeper. (Above, Patricia Dudley Goulart; below, Harrell Edward Coffer.)

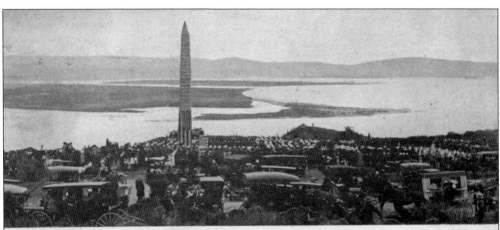

BENNINGTON MONUMENT DEDICATION, POINT LOMA, SAN DIEGO, CALIF., JAN. 7TH., 1908.
THIS MONUMENT WAS ERECTED IN MEMORY OF THE SAILORS WHO LOST THEIR LIVES BY AN EXPLOSION ON THE
U. S. S. BENNINGTON IN SAN DIEGO BAY, JULY 21, 1905.

A NOBLE TRIBUTE.

Brothers, you have gone before us into eternal rest, through the grim portal of suffering and pain, but you have left us, who linger, the lamp of your example to shine so long as our navy shall exist, cherishing its living and mourning those who fell at their post. From this sacred spot the youth of our broad country who enter its service will draw fresh inspiration. Living, they will be cared for and helped along their way. And when the last summons shall come, finer eulogy they cannot receive, than that they met their fate as bravely, as loyally and as unregrettingly as did the dead of the U. S. S. Bennington.—*From Admiral Goodrich's Address at the Bennington Monument.*

PHOTO BY S. SUTCLIFFE, SAN DIEGO, CAL.

TOUGH TIMES. The nation was recuperating from the Wall Street crash of 1929, a symptom of the Great Depression to come. Unemployment, poverty, and fear devastated families across the country. For federal lighthouse keepers, times were tough but manageable. They, at least, had jobs and homes. First assistant James Dudley (at left, with his wife, Violet) and second assistant Milford Johnson (below, with his wife, Louise, and daughter Lexie), who arrived in 1931, sought clever means to make ends meet. Each was a jack-of-all-trades, engaged in farming and gardening, carpentry, painting, road mending, tree trimming, fishing, and of course the skills required for maintaining the light. The station grounds and lantern were cared for competently—pride in their work (and unannounced visits by lighthouse inspector Captain Rhodes) their motivation. Note the Lighthouse Service–issued hat in Dudley's hand. (Both Patricia Dudley Goulart.)

FROM LEFT TO RIGHT ARE PATTY, LEXIE, AND JOAN, 1933. These neighbor kids were raised during their fathers' tenure at the lighthouse and under their mothers' watchful eye. Little more than a picket fence separated the children from the surrounding ocean. Three years later, guests who were driving downhill toward the Dudley home found Patty and her younger sister Joan ambling uphill, out of the compound. Did someone leave a gate unlatched? (Lexie Johnson.)

CHILD'S PLAY. Looking a bit like Alice in her wonderland, Joan finds a garden to pose with Shirley Temple. Joan says, "Mother made sure we had nice clothes and was a wonderful seamstress." Her children loved exploring tide pools and followed a path along the cliffs to the beach. An occasional baby octopus was toted to school in the guise of science. (Joan Dudley Eayrs.)

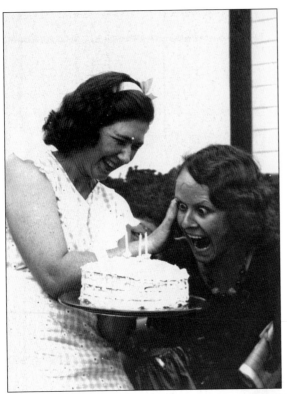

BIRTHDAY SILLIES, 1934. A quick camera catches the fun between neighbors Violet Dudley, at left balancing the cake, and Louise Johnson as they celebrate Patty's third birthday. Her cake was baked in a coal-fired oven, one the family used until the late 1940s. "I singed eyelashes more than once over the years," Pat remembers. Below, Lexie and Patty resist the cake for another minute. Birthdays came and went, and the children, by virtue of their lighthouse home, witnessed the costly errors of sailors at sea. One night, 12 sailors in a U.S. Navy dinghy cut too short across the Point and capsized in incoming surf. After rescuing the crew, keeper James Dudley went to the house and told his daughters not to laugh. Joan recalls that sailors warmed in bathtubs in all three houses, "Dad fussed that the navy ought to have known better." (Both Patricia Dudley Goulart.)

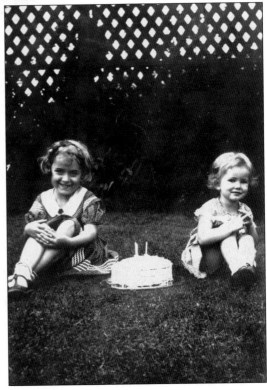

PETS ALLOWED. Lighthouse families loved many pets over the years. Here Patty (left) and Joan Dudley urge Sky to smile. Joan remembers when a Russian wolfhound washed ashore. The keeper's family found the dog another home, since shorthair dogs were best suited for Point Loma's weedy, cactus-choked terrain. (Joan Dudley Eayrs.)

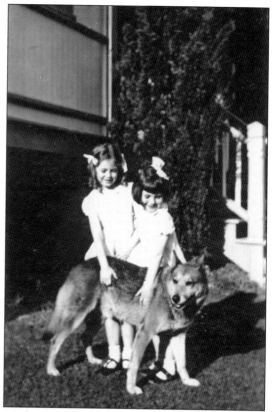

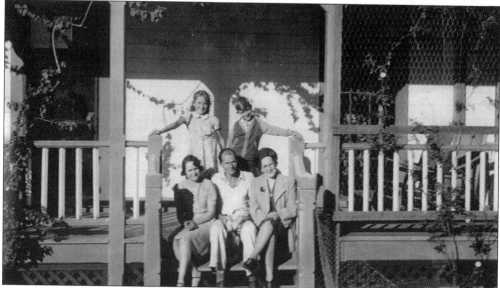

HAPPY GATHERING SPOT. The side porches of lighthouse dwellings seemed the perfect spots to gather for conversation. Johnson family members pictured here are, from left to right (sitting) Louise, Milford, and aunt Marie Cooley; (standing) Lexie and Jerry Key. Notice the large windows behind the family. Lexie remembers, "We had French windows big enough to slide up and walk through . . . six feet, great ventilation." These windows have since been replaced. (Lexie Johnson.)

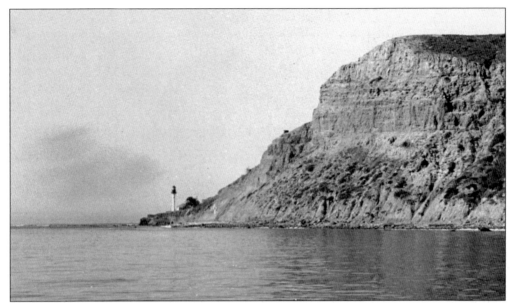

ELECTRIC LIGHTS. Note the geographic asperity (above) for bringing electricity to Point Loma Light Station. Though electric cables were laid across San Diego Bay in 1909, it was not until 1924 that the superintendent of lighthouses requested an extension of the San Diego Consolidated Gas and Electric Company's 11,000-volt power line. Fort Rosecrans's commanding officer granted the request, and the lighthouse was wired for electricity in 1926. Families continued burning kerosene lamps another seven years. Furthermore, because electric beacons seemed impractical, keepers were unwilling to yield to the modern innovation. Finally, in 1933, electric poles were raised (below), and a current was sent up the tower to a 500-watt globe, producing 200,000 candlepower of light. (Above, Lexie Johnson; below, Patricia Dudley Goulart.)

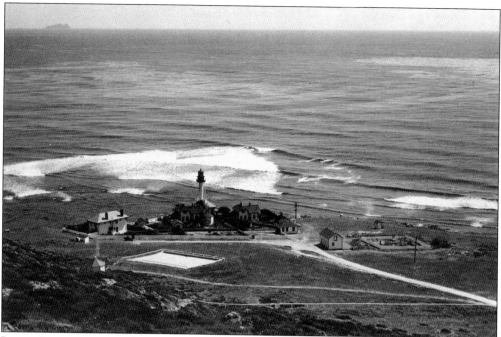

LIGHT STATION WATERWORKS. Rain was collected in an 80-foot patch of cement that formed the water shed, or catch basin. Low, concrete walls on three sides raised its capacity to 12,000 gallons. Water flowed downhill through a pipeline into storage tanks next to the dwellings. By 1907, the water supply was connected with the distributing system at Fort Rosecrans. (Joan Dudley Eayrs.)

LIGHTHOUSE FARMYARD. Keepers tended the light by night and livestock by day—along with eight hours of lighthouse work. Note the farmyard in each of the photographs on this page. In 1907, cypress trees were planted to provide a break against offshore winds. A large radio beacon tower serves the station's radio, located inside the engine house. Note the empty landscape beyond the farmyard. (Patricia Dudley Goulart.)

RAISING CHICKENS. Keepers Milford Johnson and James Dudley raised vegetables, fruits, and farm animals to help feed their families. Their monthly incomes in the 1930s were a meager $95, of which $25 was paid in rent. Above, white leghorns roam the farmyard. "Whites" lay large white eggs, which Violet sold to soldiers, workmates at the Navy Electronics Lab, and Thursday Club bridge players. It was not uncommon for soldiers to come to the aid of a chicken by shooting a fox, coyote, or bobcat, seen below with James Dudley. In another incident, Violet set out for work and discovered an area outside the compound covered in white feathers and a coyote carrying yet another chicken in its mouth. A few days later, the coyote found it was no match for armed guards. (Above, Patricia Dudley Goulart; below, Joan Dudley Eayrs.)

TURKEY DINNER. Old Tom the turkey had a habit of chasing the girls when they went into the picket enclosure for feeding time. Here the fowl seem unmoved by Dudley's guests. One of the visitors may be Dudley's good friend Holly, whom he met while serving as "chief, cook, and bottle washer" at Los Angeles Harbor Lighthouse. (Joan Dudley Eayrs.)

BROWNIE, THE MILK COW. Shown with her calf, Brownie bears the distinction of having strolled up to the post cemetery while the family was away. The bovine munched a row of branches from a star pine, the row still missing today. Back home, a note was found on the garage door advising that Brownie was waiting at the cemetery for her owner. (Patricia Dudley Goulart.)

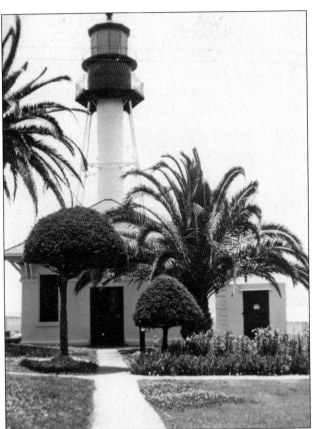

ATTENTION TO DETAIL. Lighthouse child Ken Franke once remarked, "A light station was home to a light keeper and there was no committee to beautify it. Keepers were permitted to make it beautiful in any way they could." Johnson and Dudley did just that. Even the cypress trees were trimmed to a cone shape. (Lexie Johnson.)

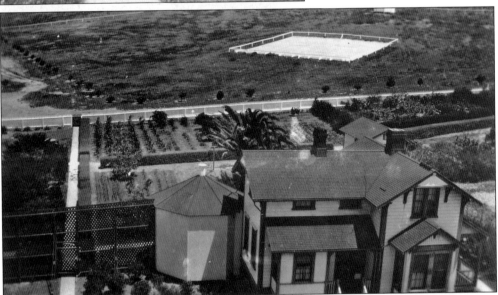

BEAUTIFUL GARDEN. Lexie Johnson states that during her time there the whole station was a big, beautiful garden, "Dad had *so* many flowers—roses, poinsettias, Easter lilies, everything, and all kinds of vegetables, berries, fruit. He also had a big garden on the side of the hill near the old water basin [above center]." Speaking of big, look at the water storage tank. (Lexie Johnson.)

HIGH HEELS. "Mother always wore them, even with housedresses and while gardening," remembers Lexie Johnson. When the lighthouse tender *Lupine* stopped in San Diego, Louise Johnson was ready to greet Capt. R. N. Rhodes, the "tyrant" 18th District lighthouse inspector. He literally ran a white glove above the door jams. (Lexie Johnson.)

PRIZE DAHLIAS. The fruits of her husband's labor, these dinner-plate dahlias are larger than Violet's pretty face. Dahlias, however, were the gentler side of living on the Point; the gun-bearing bunkers were visible from the keepers' gardens. A 50-mm anti-aircraft machine gun stood 70 feet from the house. Violet's children each wore dog tags and were practiced in the use of gas masks. (Patricia Dudley Goulart.)

RUMBLE. First assistant keeper George Cottingham sets out in his 1928 Packard Eight, with James Dudley in the rumble seat. Cottingham served at Point Loma Lighthouse from 1924 to approximately 1935. (Patricia Dudley Goulart.)

POINT LOMA'S THREE KEEPERS, 1938. Head keeper George Cobb retired in this year, just missing the 1939 transfer of the Bureau of Lighthouses to the U.S. Coast Guard. The timing of his retirement may have been intentional with the coming change of administration. Pictured from left to right are Jim Dudley, Louise Johnson, George Cobb, Theodora Cobb (lovingly referred to as "Mother Cobb"), and Milford Johnson. (Lexie Johnson.)

THE PICNIC, 1936. Three keepers and their families set aside lighthouse duties and dress up for lunch out. Note the light tower above. In his regulation cap, head keeper George Cobb sits with his wife, Theodora, and Louise and Milford Johnson. On the rough 'n' ready bench are Lexie Johnson (front left) and Patty, Joan, Violet, and James Dudley. Lexie's cousin Franklin sits near a china teapot—no plastic utensils at this picnic! Below, in a move out of character for the genteel, all-business keeper, George Cobb raises a hotdog to the camera. For little Lexie, however, hammin' it up comes quite naturally. (Above, Lexie Johnson; below, Patricia Dudley Goulart.)

CRASH LANDINGS. A glider crashes behind the buggy barn in the mid-1930s. Joan recalls several downed planes, one in which a fighter pilot bailed and then came to the lighthouse. "He asked if we would find his goggles, gloves, and scarf. We did, but a cactus traveled up my leg as I hunted. Mom had to pull out all those spikes with tweezers." (Patricia Dudley Goulart.)

BARQUENTINE CALIFORNIA AGROUND. Caught in dense fog, Capt. Edward Barr and 50 passengers experienced "the bone crunching" of this 83-footer. All hands were saved. Designed by a 16-year-old naval architect, the *California* ran the 1936 Trans Pacific Yacht Race and served as a spy ship during World War II. She was launched in 1935 and destroyed on the shelf below the lighthouse in 1981. (Photograph by Bob Covarrubias.)

150TH ANNIVERSARY ANNOUNCEMENT.
In 1939, the U.S. Lighthouse Service
was absorbed by the U.S. Coast Guard.
Americans were encouraged to visit a
lighthouse during the week of August 7 to
commemorate the long history. Those who
saved their *Guide to Historically Famous
Lighthouses* own a valuable document
today. (Patricia Dudley Goulart.)

BMC DUDLEY IN DRESS BLUES, C. 1949.
James Dudley's daughters remember that
their father "was a very hard man and
loved his work. Dad was very good with
electronics and could build anything, even
the garage behind the big house." Born
in 1903, Dudley was promoted to head
keeper at Point Loma in 1938 and officer
in charge in 1939. (Joan Dudley Eayrs.)

CELESTIAL NAVIGATION. Navigators have depended upon the sextant in celestial navigation for 300 years. The odd-looking instrument measures the angle of a celestial body above a horizontal line of reference. James Dudley, wearing his seaman's uniform, looks to the horizon through the angled mirrors of a sextant in the early 1940s. (Patricia Dudley Goulart.)

NOTICE TO MARINERS. While the officer in charge, Dudley used a blank *Notice to Mariners* to casually jot a list of former keepers. Issued by the Department of Commerce Lighthouse Service, notices were distributed to inform mariners of changes in navigational signal. For example, when Point Loma Lighthouse was reestablished in 1891, operation did not begin until 30 days' notice was given. (Patricia Dudley Goulart.)

HAM RADIO STATION. Prevalent in the early 1940s, amateur radio operators were often called into war service, but James Dudley had become interested in wireless communication years earlier. He built his own Ham radio set and operated from the family room in the head keeper's dwelling. Approximately 16 panels made up the transmitter. In the above photograph, the receiver sits on the right side of the desk. Note the speaker on the floor to the left; the Morse key unit, tuners, dials, and microphone are on the desktop, and Jim's cigarettes are nearby. Dudley's daughters Joan and Pat have a vague recollection that their father was in the wireless loop looking for Amelia Earhart sometime after her disappearance in July 1937. Shown below is Dudley's Ham radio call card. (Above, Patricia Dudley Goulart; below, Joan Dudley Eayrs.)

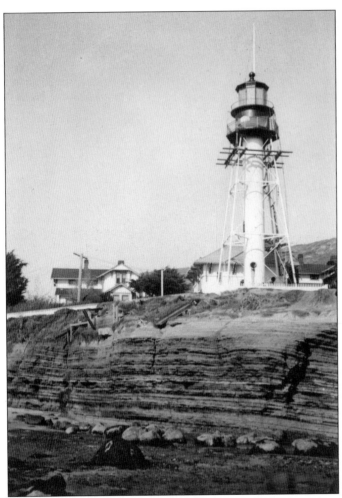

PAINTING THE TOWER, 1940. At left, scaffolding wraps the light tower while keepers spruce it up with a dose of white paint. In another few months, however, they will paint it again—in a war coat of olive drab. With the coming attack on Pearl Harbor, the lighthouse will go dark, the sound signal silenced. Dwellings, outbuildings, fences, and even the sidewalks will hide under dark paint. In the photograph below, note some of outbuildings maintained by keepers. Seen from left to right are the chicken coop, carpenter's shop, paint locker (complete with lead paint), Lexie's outhouse den, and electric room. Keepers also filled in potholes on the road. During the blackout, Milford Johnson rigged a light under the front fender of his car so he could partially see coming down the hill at night. (Both Lexie Johnson.)

GREETINGS, 1941. The Port of San Diego addressed a Christmas card to "Point Loma Lighthouse Keeper" 10 days after Pearl Harbor. Its 3¢ stamp identifies concern for the war, reading "For Defense." Further evidence is the San Diego–built Consolidated X-PB2Y-1 aircraft flying above the *Star of India*. Port director J. W. Brennan's name appears on the card. His father was the second keeper at the new lighthouse. (Joan Dudley Eayrs.)

THE PORT OF SAN DIEGO

extends Hearty Good Wishes for Happiness and Prosperity as the Old Clipper, like the Old Year, gives way to the New Clipper and the New Year.

HARBOR COMMISSIONERS
GEN. R. H. VAN DEMAN, President
EMIL KLICKA
W. E. HARPER

PORT DIRECTOR
J. W. BRENNAN

CHRISTMAS, 1937. During the Depression years, Christmas for Dudley's children meant a few small gifts under the tree that, according to daughter Patricia, "Dad chose himself. Lighthouse neighbors from Ballast Point came over for eggnog and old-fashioned fruitcake, homemade plum pudding with flamed brandy sauce, turkey grown in dad's yard. We ate fried garden parsnips, rutabagas, and cranberry sauce. And lobster from our own rocks." (Patricia Dudley Goulart.)

LIGHTS OUT OVER POINT LOMA. Immediately after the Japanese attacked Pearl Harbor on December 7, 1941, a blackout was ordered, and lighthouse personnel painted everything olive drab, seen above. Tar paper covered windows to block the light. The camouflage effect was intended to deter the enemy at the entrance to San Diego Bay, Japan's nearest American neighbor. "We had a tremendous scare one night," Lexie remembers. "It was believed a German submarine slipped through nets at the harbor entrance. All hands were required to report with available guns and ammunition. Dad and Mr. Dudley went out on the bay in a rowboat with a shotgun and .22." Below, houses await the removal of their green color. The tower was likely repainted white before all else. (Above, Lexie Johnson; below, Patricia Dudley Goulart.)

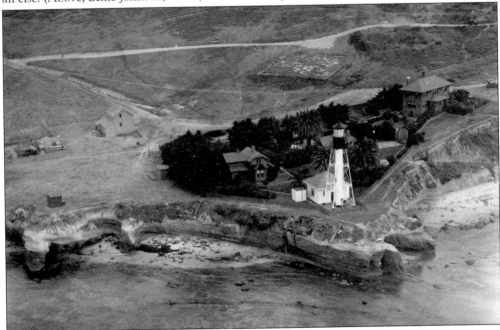

DUDLEY IN THE LIGHTHOUSE RADIO ROOM. Radio beacon apparatus was installed in the engine house in 1926. "Dad was very good with electronics," says Dudley's daughter Pat. "During the war he was in charge of the LORAN station (long-range navigation) across from the cemetery." Radar was used to spot vessels on the water by timing the intervals between the signals received from three or more stations. (Patricia Dudley Goulart.)

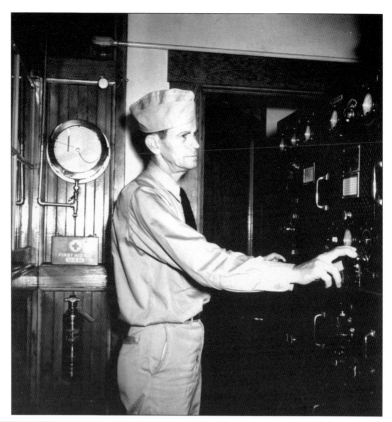

WAR BABY, 1944. "Yes, mom had a wartime baby, but dad never went to war—he battled it on the home front," Joan recalls. The Dudley infant spent his first night in a laundry basket at Hillside Hospital because the facility had run short of cribs. Robert, at age four, leans against an abandoned bunker high on Point Loma in 1947. (Joan Dudley Eayrs.)

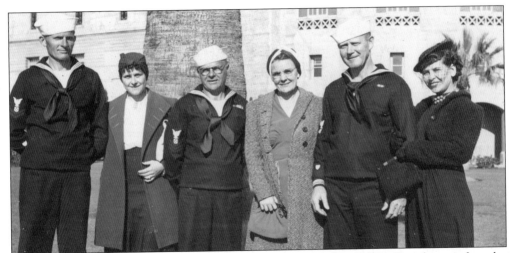

U.S. Coast Guard Lighthouse Personnel, 1942. With World War II underway, the roles of some keepers were rearranged to accommodate the war effort, but good friends stayed close. Pictured from left to right are BM2 Milford Johnson and his wife, Louise; Ballast Point BM2 Steve Pozanac and his wife, Minnie; and BM2 Charlie and Mrs. Livesay from Point Vicente Lighthouse in Palos Verdes. (Lexie Johnson.)

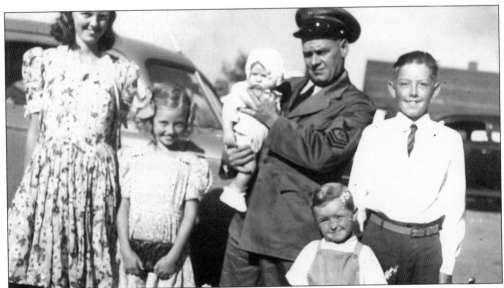

New Assistant at Point Loma Lighthouse. Second assistant John Slater arrived at the station shortly after the war, having served as a boiler tender aboard U.S. Coast Guard vessels. Shown here with his own children and likely some nephews, Slater stayed just two years in San Diego. (Joan Dudley Eayrs.)

KEEPERS' KIDS, 1944. John Slater's children and their neighbor Robert Dudley (fourth from the top) line the porch steps where many before them have gathered. Robert's sister Joan remembers that Slater's plump wife, Mitzi, visited the doctor for what she thought was a tumor in her belly. It ended up being the son waving on the bottom step. (Joan Dudley Eayrs.)

OUTHOUSE DEN. Lexie was almost three years old when her family moved from the Farallon Islands to Point Loma in 1931. When she was a teenager, her father renovated an old privy to provide her with an art studio consisting of a cot, desk, and window. She attended Point Loma High School, left the station in 1952, and married a Johnson four years later. (Lexie Johnson Johnson.)

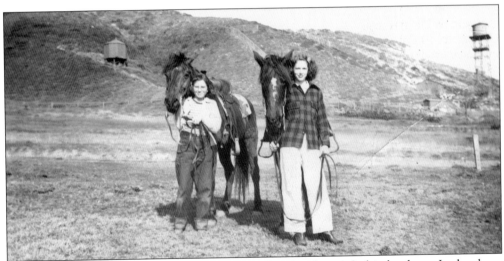

SECRET ROCKET. After the war, James Dudley bought riding horses for his daughters. In the above image, Joan (left) with Sonny and Patty with Rosita stand between the gravity-fed water tank (upper left) and the U.S. Army watchtower, which resembled a water tank. In 1946, Lexie Johnson and Patty Dudley were riding northwest of the lighthouse and came upon what Lexie described as "this big army installation and a rocket sticking out of it. Men were running around, like something out of a movie. It wasn't just a rocket—they were working on it. We told dad and he said, 'You're dreaming!'" The girls had likely come upon the MX-774, America's first ballistic missile, seen below. Convair operated a secret static-testing facility on Point Loma. The framework is a former oil derrick. (Above, Patricia Dudley Goulart; below, the San Diego Air and Space Museum.)

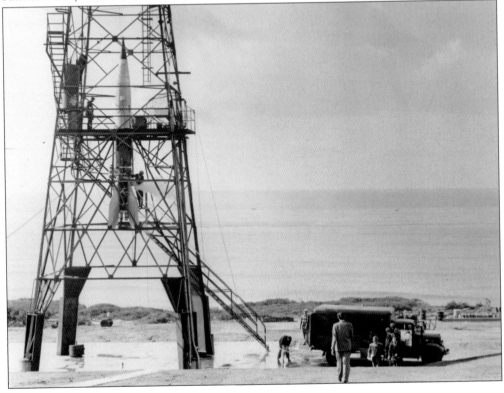

CHANGE OF LIGHTHOUSE COMMAND. At right, retiring officer in charge James Dudley formally passes the Record of Public Property to first assistant Milford Johnson (left). It states, "As of 1 February 1952 Point Loma Light Station is found to be in orderly condition." Johnson was promoted to officer in charge, but early retirement was preferable to mandatory relocation to the big house. The photograph below is remarkable because so few exist that show the clockwork (lost today) still inside the pedestal case. The original dark green paint, along with much of the bronze work, was painted gray by the Coast Guard to lessen upkeep as automation began to take over (see chapter six). Milford Johnson makes his way to the tower watch room, where years before he cranked an electric telephone to ring Dudley, asleep next door, and declare, "Your watch!" (Both Lexie Johnson.)

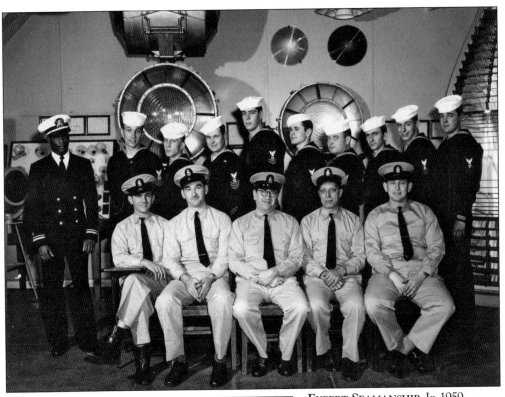

EXPERT SEAMANSHIP. In 1959, Thomas C. Calderwood was assigned to the coveted Point Loma Light Station in lieu of a medal for a remarkable early career of rescues at sea. Enlisting in the Coast Guard in 1947 at age 17, he had served aboard cutters such as the 255-foot *Pontchartrain* during the rescue of passengers of the Pan American Stratocruiser's mid-Pacific ditching. In 1956, Calderwood (standing, second to the left) graduated from the Aids to Navigation School in Groton, Connecticut. Notice the first-order Fresnel lens and giant directional code beacons. After rescuing flood victims on California's Russian River, Calderwood was sent to San Diego. At left, letters of appreciation acknowledge his personal efforts in rescues near the lighthouse and praise him for outstanding proficiency with recommendation for officer's candidacy. (Both Allan Calderwood.)

VOW OF LITERACY. Worn-out baby diapers served as this keeper's lens cloths. Thomas Calderwood (right) was one of the youngest chief petty officers in the Coast Guard in 1961. A private man, he loved being on the sea. After several rescues near Point Loma Lighthouse, Calderwood pushed (unsuccessfully) for construction of a boat ramp near the station. The Cuban Missile Crisis came under his watch, and soldiers with Tommy guns were told to "defend the lighthouse to the last hand." According to Allan Calderwood, "Dad vowed that no enlisted man would leave his command without being fully literate." Chief Calderwood taught men to read at his home until he left the station in 1962. Allan (below) wears a seaman's uniform sewn by his mother in 1958. (Both Allan Calderwood.)

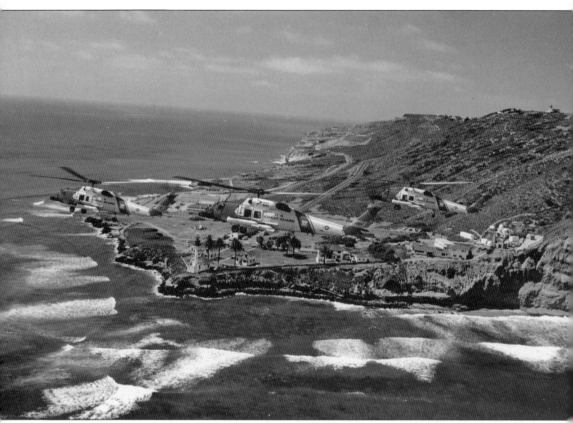

U.S. COAST GUARD PASS, 1997. Medium-range twin-engine Sikorsky HH-60 Jayhawks pass above the apex of Point Loma peninsula, both lighthouses in range. A fourth Coast Guard search-and-rescue helicopter carries photographer Stuart Hartley. Note the intricate pattern of waves as they head to shore. Point Loma Lighthouse has stood tall through more than a century of history, including some lesser-known events such as the filming of a scene from the 1986 blockbuster *Top Gun*. Toward the end of the movie, Maverick (Tom Cruise) visits the home of Viper (Tom Skerritt). The actors are standing in the living room of the lighthouse dwelling, recognizable by the stairway. Not long after, Maverick leaves by way of the old barn. The tower is not shown in the film. Paramount Pictures authorized the use of a photograph here, in the event of written consent by Mr. Cruise. The Cruise camp declined. (Stuart Hartley.)

Five

NEIGHBORHOOD LIGHTS

In the face of nationwide pessimism, California has moved forward in the ranks, holding high the banner of progress and prosperity.

—G. A. Davidson
President of the Panama-California Exposition, New Year's Day, 1915

The highlight of Queen Victoria's reign was the 1851 Great Exhibition of the Works of Industry of All Nations. Her consort, Prince Albert, was the unifying force of this first international display of products, machinery, and manufactures held within London's legendary Crystal Palace. The eminent glassmaking firm Chance Brothers supplied the structure's glass and there exhibited its first lighthouse lens.

Just as the Great Exhibition was a mammoth undertaking—politically and financially, and with the strong support of naysayers—so too was San Diego's Panama-California Exposition of 1915–1916. Initial contention between San Diego and San Francisco ultimately led both cities to stage fairs celebrating the opening of Panama's canal, which eliminated 8,000 miles of water route between coasts. San Diego, boasting its position as the first port of call after the canal, filled Balboa Park with Spanish Colonial architecture and great activity.

The U.S. Lighthouse Service placed displays within expositions. Frustratingly little is known about San Diego's; the search for photographs proves fruitless, though it remains ongoing. When San Francisco's exposition ended late in 1915, the Lighthouse Service transferred portions of that exhibit to San Diego—lenses, fog bells and strikers, lens lanterns, models of lighthouses, light vessels, and tenders. Keeper Hermann Engel received a letter of commendation from the service for voluntarily polishing lenses and brass work at what, in 1916, was rechristened the Panama-California International Exposition. For the same efforts at the 1935–1936 exposition, keepers William Mollering Radford Franke were saluted.

There was a lighthouse at the first exposition along the Isthmus. Two other neighborhood lighthouses have not been so transient. One is a beacon in a picturesque tower that tops a restaurant built upon spoils dredged from San Diego Bay. Another is a young lighthouse standing beside a very high fence separating two nations.

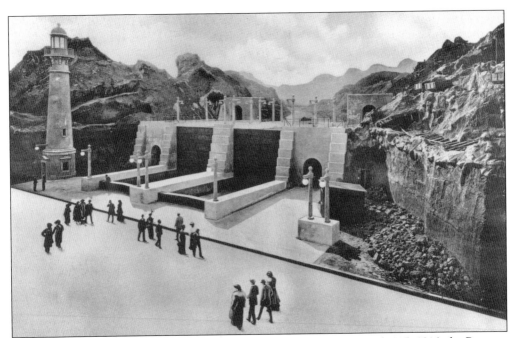

MINIATURE PANAMA CANAL. During the Panama-Pacific Exposition of 1915–1916, the Panama Extravaganza was a scale model of the Panama Canal offering the opportunity to see the exact manner of its operation. The lighthouse was a real beacon showing visitors the entrance of the Isthmus Extravaganza. Photographs of the event have yet to be encountered, while postcards tend to give a comedic effect. (SDHS.)

4422. "The Isthmus" Amusement Street, Panama Canal on left, Panama-California Exposition, San Diego, 1915.

ALONG THE ISTHMUS. The Isthmus was a "street of amusements." In this postcard, the lighthouse stands to the left and the canal entrance to its far side. The features, as noted in a booklet *Exposition Beautiful*, were the Temple of Mirth, the Toadstool, the Yelps, and Kelly's: "All four are places for mirthfulness and jollity."

Faro Maritimo de Gobernacion.
On the south side of the fence
bordering the United States and
Mexico is a 20-meter lighthouse,
its winking eye visible from Point
Loma at night. The bustling town of
Tijuana, Mexico, runs right to the
door of the tiny, attached dwelling.
Note the bullring of *Playas de Tijuana*
directly behind the lighthouse.

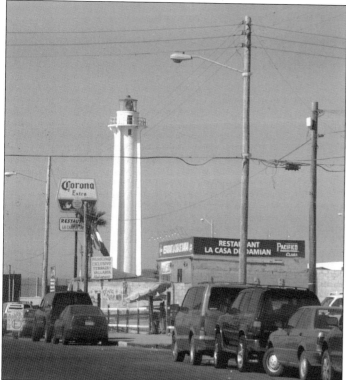

**Lighthouse at the
Border.** *Capitania
de Puerto de Ensenada*
maintains 10 federally
operated lighthouses along
the Baja coast, including
Tijuana Light, constructed
in 1980. Soldiers residing
on Mexico's Coronados
Islands tend two lights
on the far side of the
island chain. Notice the
border fence, low and to
left of the lighthouse.

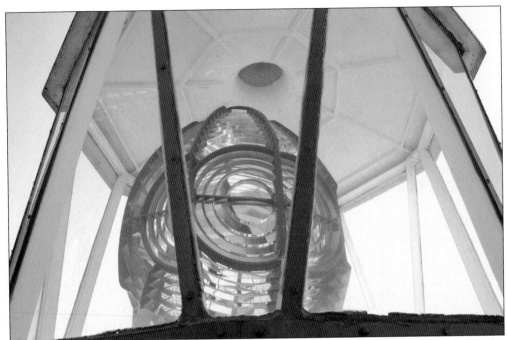

QUICK-FLASH BIVALVE LENS. Unaccompanied by a handrail, 113 bright red steps wind to the tower top. The keeper of the light, chief of naval service Jose Ramirez Alarcon (on ladder to the lantern in the image below), simply flips a switch in his living room to light the 1,000-watt bulb inside the lens. Four quick flashes followed by three-second intervals identify Tijuana Light.

CHIEF OF NAVAL SERVICE. Alarcon keeps his ladder red, too, inside the white, round tower surrounded by four supporting buttresses. The keeper is required to check in by phone to Ensenada Operations twice every day. At the top of the lighthouse, the railing around the outside gallery is slightly higher than one's knees.

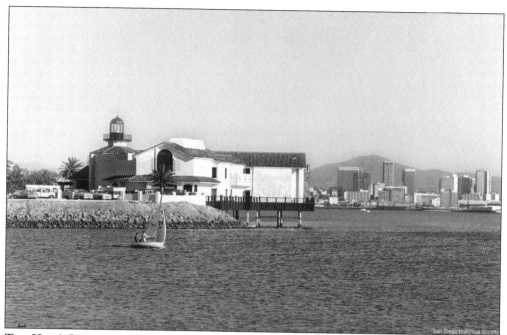

TOM HAM'S LIGHTHOUSE RESTAURANT, 1971. "There was nothing else out there on that island," remembers Gene Trepte, the builder of Ham's lighthouse vision. "It was all his idea. We drove the piles and put half the place out over the water." Harbor Island was just new, having been formed with dredged material from the deepening of North Island's aircraft carrier basin. (SDHS.)

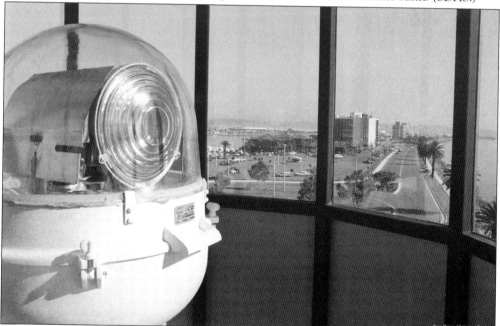

HARBOR ISLAND LIGHT. Yes, Harbor Island Light is a real aid to navigation. Commissioned as U.S. Coast Guard Beacon No. 9 in January 1971, the DCB-10 in the restaurant's rooftop lantern has a focal plane 55 feet above the water. Ham's daughter Susie and her husband, Larry Baumann, have stayed her father's lighthouse course on San Diego Bay. (SDHS.)

TODAY'S LIGHTHOUSE KEEPER. The U.S. Coast Guard Aids to Navigation Team in San Diego maintains numerous bay beacons, including Point Loma Lighthouse. Above, EM2 Francisco Javier Lopez climbs to Harbor Island Light (USCG Light List No. 1700). Below, Lopez demonstrates the operation of the automatic lamp changer in the 300-mm beacon installed in 1982. He tells a funny story from Christmas Eve in 2005. Lopez called the operations center to inquire about the status of Point Loma Light. Asking the watchstander to direct the monitoring camera toward it, the center reported "no visible rotation." Lopez phoned for assistance to meet at the lighthouse, where he found a "full range of beams and good smooth rotation." The watchstander reviewed the shot to find that he had looked at Old Point Loma Lighthouse—inspiring Lopez to cry out, "Merry Christmas to all, and to all a good light!"

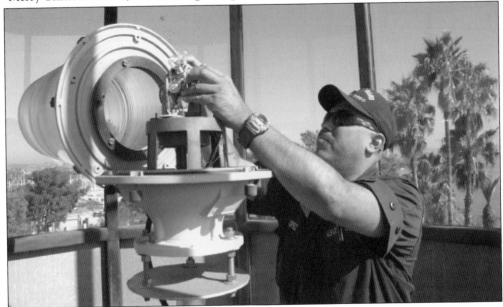

Six

SAFEKEEPING

Fresnel's great talent was not just in developing new theories and a new understanding of light and its diffraction, refraction and reflection, but also in his abilities to create practical experiments to prove his theories. In the case of his lighthouse work, he was able to create usable designs that not only performed the required function, but which could easily be manufactured and implemented.

—Thomas A. Tag, historian

Time and sea air had taken a harsh toll on the skeletal tower and lantern of the 1891 Point Loma Lighthouse. Ironwork had become severely corroded, and rust-jacking caused pushing and expansion against adjoining seams. Small gaps opened within the structure itself. The resultant deformation exerted enough force to crack and warp the heavily constructed lighthouse tower. Seismic activity likely further contributed to the tower's instability. Not altogether blameless, however necessary, may have been the automation and changing duties of the U.S. Coast Guard.

By 1997, the rotation of the glorious Fresnel lens was overcome. The flooring of the lantern's watch room was out of level and plumb. The valuable optic could only be preserved through its removal, which occurred in late 2002. Cabrillo National Monument had long planned a new home for the optic. In 2005, the Assistant Keepers Quarters was rebuilt on the site and plan of the original, which had stood beside the first Point Loma Lighthouse. The structure is a brilliant (literally) and permanent display for the beautiful-but-all-business lighthouse optics that once lighted the way into and out of San Diego.

The authors had the special opportunity to assist during the optic's removal from the lighthouse and also during reassembly in the Assistant Keepers Quarters. Karen was a runner (round, round, up and down) and Kim project photographer.

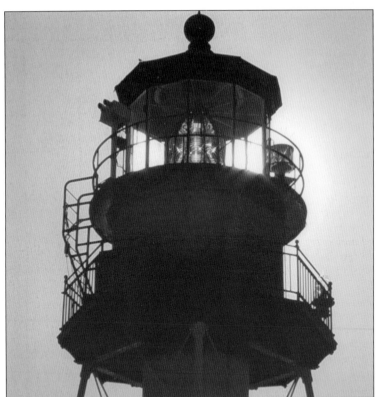

ONE LAST NIGHT. Gray pervades the sky as the setting sun shimmers its ethereal farewell to an old friend. The lens of Point Loma Lighthouse must give up its place when morning comes. A specialist team of the U.S. Coast Guard will begin the process to remove the lens after 111 years in the lantern.

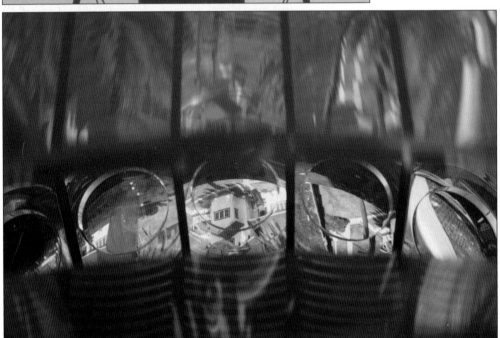

UPSIDE DOWN. When viewed from a distance, the central, curved sections of a lighthouse lens will invert whatever is seen through them. Peek through the bull's-eyes here; notice the station dwellings and sidewalks, which appear upside down.

MOTOR BURNOUT. The misaligned floor was destructive to the lens, which was not contacting all chariot wheels for proper rotation. Shifting its weight, the lens rocked from contact point to contact point. Stress on the upper stability rollers wore a groove in the chimney assembly, and motor strain became too great. Rotation of the 1887 third-order flashing lens stopped for good in late 1997. The secondary beacon immediately assumed sending one flash every 15 seconds. In time that was replaced by a 250-mm Vega rotating beacon, seen at right through the lantern window and below through a Fresnel lens bull's-eye. Though plastic beacons lack appeal, their construction is based on the same principles for intensifying light.

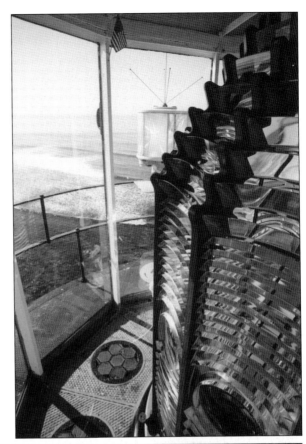

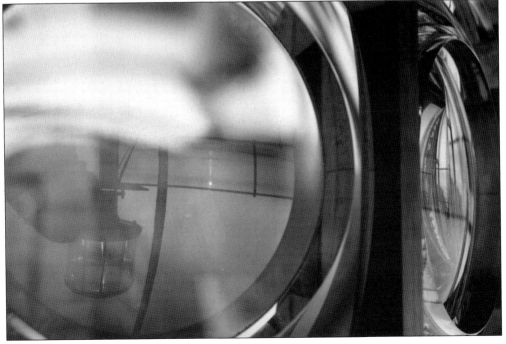

BEYOND A POINT OF RETURN. The central post—running the entire height of the lighthouse tower and attached to the interior watch room floor—is separated from the floor at least a quarter inch, as shown above. In the lantern decking, or floor, are holes through which ground is seen. Deterioration, even detachment, of the lantern's exterior ironwork is evident in the close-up view below. The photograph was taken from the ground looking up to the underside of the lantern deck. The sorry, old lighthouse is now rated *condemned*. The three dwellings in this otherwise idyllic setting have always been given attention to their upkeep. U.S. Coast Guard personnel occupy them today; however, all lighthouse-related activity is the responsibility of the Aids to Navigation Team, not the residents.

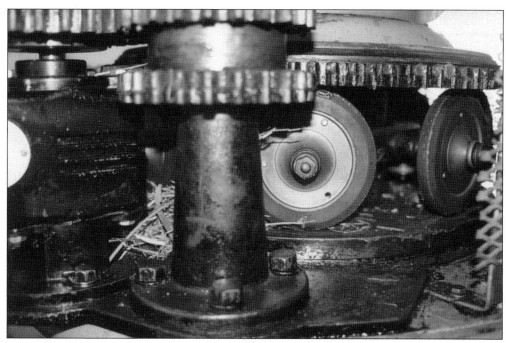

ECONOMICS DICTATE. Gone are the days when regular attention to the lens came with morning light. Automation brought the de-manning of light stations countrywide. Without consistent human maintenance, the already aged structures could not remain preserved. Even the birds nesting behind the chariot wheels of Point Loma's lens understood.

DISASSEMBLY. Many components comprise a lighthouse lens. Before the framework of glass and bronze can be dismantled, certain metalwork of the supporting pedestal must come away. Already, the incandescent oil vapor tank is removed from the lamp stand inside the lens (when the lighthouse was electrified, the electric box and lamps were fitted to the tank). In its turn, so goes the skirt, or murrette.

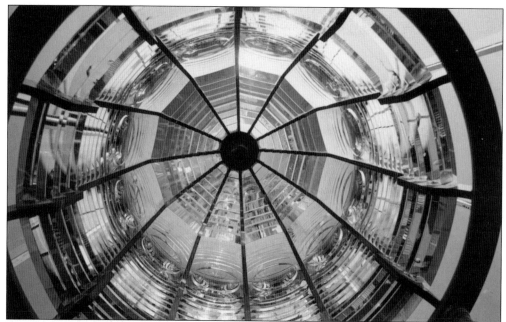

UNIQUE VIEW. This vantage can only be captured when the lamp stand is out of the way. From inside the lens, reflections are wonderful in all the colors of sky, grass, cliffs, ocean, and rooftops. The dark circle is the base ring onto which the prism panels are bolted. Imagine the rotation—at sea, each bull's-eye gave the appearance of a flash rather than an actual light switching on and off.

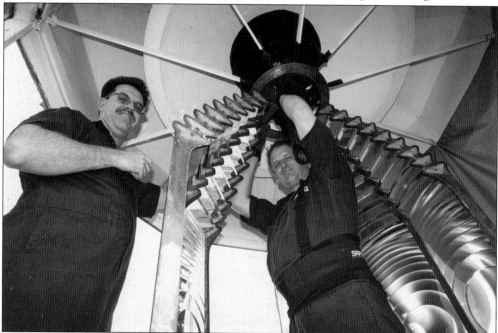

UNMISTAKABLE EVIDENCE. As the first prism panel was skillfully nudged and dislodged from its mates, an audible and palpable release of torque, twisting, and tension validated the removal of the lens. Here all but 4 of the 12 prism panels of the Henry-Lepaute lens have been disassembled. Shown are chief warrant officers Joseph Cocking (left), who headed the project, and Anthony Farr.

"Space is Killin' Us!" Rope that was wrapped around the lantern and passed through a block became hoisting tackle, necessary for lowering all items from the lantern. In the round space of a lighthouse lantern, an oblong crate does not maneuver easily. But one by one, each 75-pound lens panel was bubble wrapped in the upper lens room, manhandled down steps to the watch room, and fitted securely into its custom crate.

Out and Down. Confident and adept, the men lowered 12 crates of glass and tons of ironwork from the lantern gallery to the ground. Note the lines at either end of the crate that provide control from the ground.

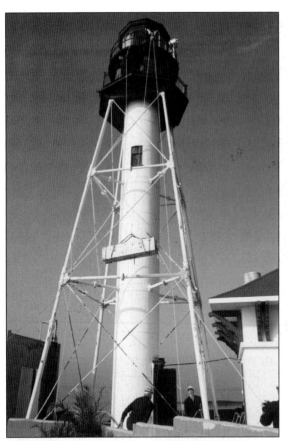

A PANEL COMING DOWN. Point Loma Lighthouse may be the only skeleton-style lighthouse on the West Coast. Some sources suggest the skeletal tower displayed in Chicago's 1893 World's Columbian Exposition was transferred to the Northwest; others contradict this statement. The stairwell inside the tower is too narrow for carrying anything much larger than a 5-gallon oil container.

HEAVE! Not without extremes of effort was the weighty cantilever hefted from the pedestal base. This image further reveals the space restrictions within the watch room and the exceptionally narrow stairs to the lens room. From left to right, beginning with the half-gloved hands of Rob Schaffer at the bottom, the team consists of Dave Curran, Milton Waite, Joe Cocking, and Tony Farr, all since retired from the U.S. Coast Guard.

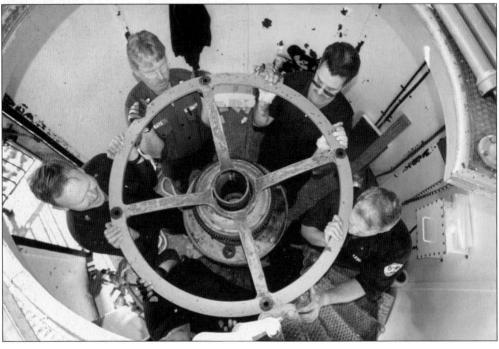

LURING THE LURE. The combination of certain metals fitted together for 111 years gave fair challenge, but the men have finally succeeded in separating the lure, or connecting tube, from the crown piece. Long ago, it connected with the kerosene lamp's glass chimney to release heat through the ventilator ball on the lighthouse top. Note the pretty deck prisms, which add light to the watch room.

NEW HOME. Cabrillo National Monument stored the Point Loma Lighthouse lens until the Assistant Keepers Quarters was constructed. Pictured here from left to right in July 2004 are Nick Johnston, Nick Johnston Jr., Tony Farr, and Joe Cocking beginning its reassembly. The clockwork case at the bottom bears all the weight. Here the platen, or table, is lifted onto the cantilever. A six-foot-deep pit was provided in an effort to display the entire mechanism while also staying within the preestablished structure height.

HENRY-LEPAUTE NO. 329. The first lens panel is being positioned. What the photograph barely shows are the tiny wooden wedges inserted by the manufactory all those years ago to secure correct prism placement. The shock-absorbing wedges kept bronze from touching glass. All was secured by putty, which contained litharge—lead monoxide—known today to be a breathing hazard.

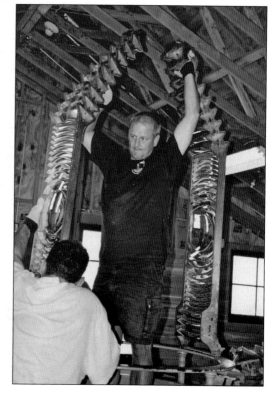

DO NOT BREATHE. Tony Farr dare not sneeze while balancing the first and second lens panels as they are bolted to the base ring and then secured at the top by the upper guide assembly. On each lens panel, the factory embossed a number indicating its position within the whole, so the second panel to be installed is not the panel numbered 2, but the one numbered 6.

A Rare View. Lens assembly is nearing completion. How many years will pass before the manufacturer's green and blue inscriptions on the base ring will again be seen? These inscriptions would have indicated maker's marks for the specifications of drill holes and also for determining the inside center for the exact focal placement of the lamp or light source.

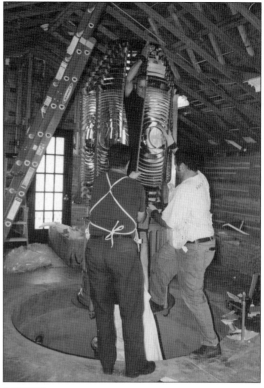

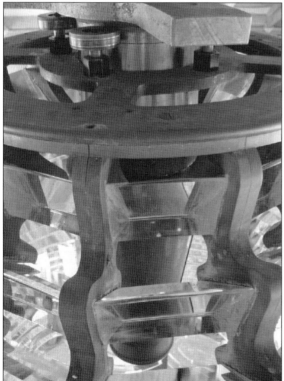

A Short Lesson. Study this slightly confusing view to see what the top apparatus of the lens looks like. The upper guide roller assembly (small wheels) attaches to the crown piece, which circles the central support of the optic. Peek through the upper "catadioptric" prisms; there is the lure that once connected to the glass chimney of the lamp to vent the heat and smoke.

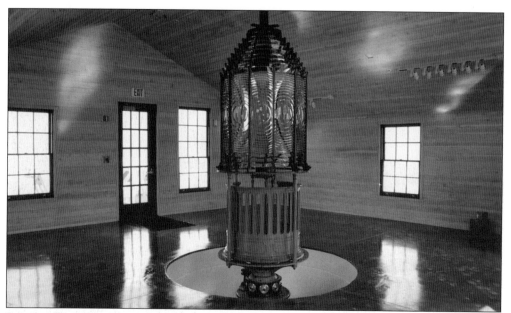

SECOND BEST PLACE TO BE. Alas, the Point Loma Lighthouse lens can now broadcast its beams only to walls—no more to the Pacific. CNM's new Assistant Keepers Quarters now offers safekeeping for the optic and will soon be in the company of an award-winning exhibition about the lighthouses of Point Loma.

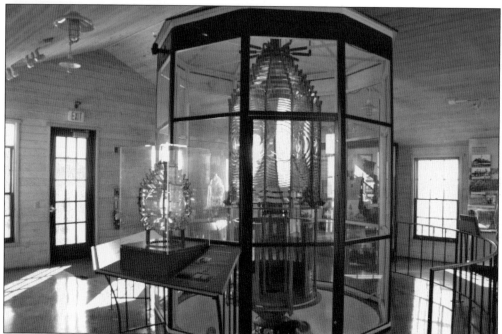

EXCEPTIONAL COLLECTION. A faux lantern and gallery railing—made to look like those at the lighthouse—provide protection for the lens in the Assistant Keepers Quarters. The fifth-order optic from Ballast Point is seen left of Point Loma's lens. Peek between and behind the two to see the Vega beacon that originally flashed the signal from Point Loma Lighthouse after the rotation of its lens was stopped.

"THE PLEASURE OF BEING SAD." Victor Hugo adequately described the feelings as people reunite. This page and the next illustrate special reunions with some of the people who grew up at San Diego's light stations. In March 2003, Kenneth Franke (left) and Alton Sweet stand near a photograph of Ballast Point Light Station, each holding a portrait of himself as a child living there, generations apart.

REMEMBERING. Jeannette Mollering Johnson holds a photograph of her father, William (see page 49). On the night of her senior prom in 1938, the year of his death, she visited the cemetery on the Point and placed her corsage of seven mystery gardenias on his grave. The more flowers on a corsage, the more a boyfriend cared for his date. She stated, "Mine went down to my waist!"

WHAT A FUN DAY. Another memory-filled gathering is celebrated at Point Loma Lighthouse in May 2002. Shown in the preceding chapters are other photographs taken on these same stairs (though they have perhaps been rebuilt). Gathered here on the top step, from left to right, are adult lighthouse children Patricia Dudley Goulart, Kenneth Franke, and Joan Dudley Eayrs. The children living at the station dwellings at the time were Jessie, Chris, and Kelly Strangfeld and Christina and John Collins.

HAPPY HOMECOMING. Too many miles between Florida and California kept Lexie Johnson from attending, but she enjoyed the reunion by telephone. Here Patty, Kenny, and Joan find the dwelling stairs on which they played as children a bit tight. Looking closely at the book, hopefully readers will take with them the memories and laughter displayed here.

Bibliography

Cortellini, Mary Ellen and Karen Scanlon. "A Naval Disaster in San Diego: Inter-Service Cooperation in 1905." *The Journal of America's Military Past*. Vol. 21, No. 1, Spring/Summer 2005.

Description of Light Stations. United States Coast Guard Historian's Office, Washington, DC.

Engel, Norma. *Three Beams of Light*. San Diego, CA: Tecolote Publications, 1986.

Holland, F. Ross. *The Old Point Loma Lighthouse*. San Diego, CA: Cabrillo Historical Association, 1968, 1978. Revised by Cabrillo National Monument Foundation, 2007.

———. *America's Lighthouses: An Illustrated History*. New York: Dover Publications, 1972.

Manley, William R. *National Register of Historic Places Nomination, Point Loma Light Station Historic District Report*. San Diego, CA: U.S. Coast Guard, 2003.

Moeser, June D. *Four Sentinels*. San Diego, CA. Tecolote Publications, 1991.

Reports of the Light-House Board to Congress. U.S. Lighthouse Society, San Francisco, and Nautical Research Center, Petaluma, CA.

Stetz, Debbie. "Something New at the Old Point Loma Lighthouse." *The Keeper's Log*. Vol. 13 No. 2, Winter 1997.

Sutton-Jones, Kenneth. *Pharos: The Lighthouse Yesterday, Today and Tomorrow*. Wiltshire, England: Michael Russel, 1985.

Tag, Thomas A. *The Fresnel Lens Makers, Part 3: The Henry-LePaute Lens Works*. Dayton, Ohio: 2004.

www.sandiegohistory.org (San Diego Historical Society)

The Daily Bee, San Diegan Sun, San Diego Union, and the *San Diego Tribune*.

ACROSS AMERICA, PEOPLE ARE DISCOVERING SOMETHING WONDERFUL. *THEIR HERITAGE.*

Arcadia Publishing is the leading local history publisher in the United States. With more than 4,000 titles in print and hundreds of new titles released every year, Arcadia has extensive specialized experience chronicling the history of communities and celebrating America's hidden stories, bringing to life the people, places, and events from the past. To discover the history of other communities across the nation, please visit:

www.arcadiapublishing.com

Customized search tools allow you to find regional history books about the town where you grew up, the cities where your friends and family live, the town where your parents met, or even that retirement spot you've been dreaming about.